IMAGES
of America

BEAVER CREEK

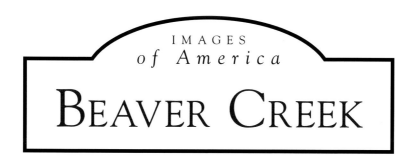

IMAGES
of America

BEAVER CREEK

Laura Chiappetta Thompson

ARCADIA
PUBLISHING

Published by Arcadia Publishing
Charleston, South Carolina

Printed in the United States of America

Library of Congress Control Number: 2014906789

For all general information, please contact Arcadia Publishing:
Telephone 843-853-2070
Fax 843-853-0044
E-mail sales@arcadiapublishing.com
For customer service and orders:
Toll-Free 1-888-313-2665

Visit us on the Internet at www.arcadiapublishing.com

*To all the adventure seekers who came to this valley over
the years and to many who have yet to arrive*

CONTENTS

ACKNOWLEDGMENTS

The suggestion for this book came from Nicole Magistro, owner of our independent bookstore, the Bookworm, in Edwards, Colorado. Nicole guided me to local library archivist Jaci Spuhler who assisted in gathering many books and photographs that set the foundation for my research. Jaci also showed me how to use the microfiche machine, which is a lost art in itself. The Eagle County Historical Society with the Eagle Public Library has developed an extensive album of historical photographs that capture the very early days of living in Beaver Creek. The Eagle County Historical Society generously under wrote the costs of these images. Authors Sherwood Stockwell, Don Simonton, and Kathy Heicher shared valuable information, images, and related resources, which were incorporated into this book. Cliff Simonton, on staff with Vail Resorts during the construction of Beaver Creek, was generous in lending me photographs for this project. A former colleague of mine, Jack Affleck, Vail Resorts, Inc., director of photography, graciously extended access to its historical photograph archive. Local photographers Mike Rawlings, Dann Coffey, Rex Keep, and Zach Mahone also shared access to their images, many of which became part of this amazing story. Numerous long-distance phone calls, e-mails, and lunches allowed me to meet folks that I otherwise would not have had the pleasure of meeting. Their input generated colorful stories, giving life to many of the characters within these pages. Kathy Macy, Carol King, Bob Dorf, Jenn Wright, Marty and Jack Mankamyer, Bill Andre, Bill Heicher, Ron and Mary Brown, Duke Hall, Roger Lessman, Jan Jouflas, Carl and Mike Eaton, and John Dakin are just a few of those people. Through the help of these people in the Eagle River Valley and beyond, this book became a reality.

I would also like to thank my editor at Arcadia Publishing, Stacia Bannerman, for patiently working with me. Two local authors, June and Don Simonton, deserve much credit in preserving and capturing the history of Beaver Creek. To my husband, whose humor and love has supported my efforts during this endeavor, as well as our life together, I could not have done it without you.

INTRODUCTION

Beaver Creek was aptly named for the industrious beavers that called the waterway home. Today, the valley is dotted with beautiful homes, while world-class accommodations surround the Southern European–style mountain village. Year-round activities abound for visitors with skiing and snowboarding the predominate winter sports. Summer recreation features golf, hiking, fly-fishing, and biking. Not long ago, adventure-seeking individuals, much like the folks that come here today, inhabited this valley.

The Homestead Act of 1862 opened the door to the Wild West. Upon filing an application for a federal land grant, an individual could apply for the 160-acre limit. Anyone was eligible if they had never taken up arms against the US government, was at least 21 years of age, and head of a household. Prior to the issuance of the final patent, or title, the owner needed to reside on and improve the land for five years.

In the book *The Utes Must Go!*, Peter R. Decker describes how Governor Pitkin forced the Utes out of Colorado to Utah in 1881. Pitkin claimed economic development in Colorado was being hindered by the presence of the Utes. With the end of the Civil War and subsequent removal of the American Indians, white settlers and miners headed into the Rocky Mountains. Primitive but beautiful, this land was full of game, edible berries, and other plants—ingredients all necessary to attract dreamers who sought a new life.

Folks came from nearby mining towns, and others travelled across the frontier from the East Coast and Europe. The following quote from local Eagle County historian Frank Doll described what the settlers found: "Life was always hard. No heat—go to the wood pile, No water take a bucket to the creek, No light—use kerosene and candles, No food—you hadn't worked hard enough." In spite of these difficulties, people came and worked the land or the railroad. The Denver & Rio Grande Railroad (D&RG) completed its route from Leadville to Aspen in 1887. Leadville townspeople depended on the lumber, crops, and wild game that the Avon-area settlers sent via the D&RG Railroad.

A new generation of dreamers came from the 10th Mountain Division, the military unit trained for combat on skis during World War II. In nearby Camp Hale, a young platoon sergeant by the name of Pete Seibert was one of those dreamers who would make Beaver Creek Resort a reality. After being severely wounded in the war, Seibert swore he would ski again and have a ski resort of his own. With his determination and good friend Earl Eaton, they scoured the areas close to Camp Hale for Seibert's ski resort. Eaton, born and raised in the Beaver Creek area, had been prospecting for uranium and knew the surrounding mountains very well. In the spring of 1957, Eaton skied with US Forest Service ranger John Burke in the area above Avon. According to Seth Marx's *The Making of Beaver Creek*, Burke shared his thoughts with Eaton that the area would be well suited for a winter sports development. Once Seibert surveyed the property, he was sure this would be the place for his ski resort. The only problem was the owner; Willis Nottingham loved his ranch lifestyle and refused to sell.

In May 1970, the International Olympic Committee (IOC) determined Colorado's Rocky Mountains were steep and challenging enough to hold Olympic events. That same year, Vail Resorts acquired the property from Nottingham to build Seibert's dream Beaver Creek ski resort. The IOC examined three different venues to hold the Alpine skiing events. Beaver Creek won the honor of hosting the Alpine events. Seibert received a second chance to build an Alpine ski village. However, environmental impact concerns, financial expenditures, and the 1972 Colorado voter referendum killed the 1976 Winter Olympics for Colorado and consequently Beaver Creek. In hindsight, Seibert and others realized losing the Olympics removed the pressure of meeting the 1976 timeline to build Beaver Creek Resort. Without this construction deadline, a coherent design of the village would be possible to achieve.

Like a cat with nine lives, Beaver Creek Resort, as Seibert envisioned it, was still a possibility. Governor Lamm was one of the biggest critics of the proposed resort along with 13 state agencies that challenged the development. The process to get approval took four and a half years of studies, money, and dialogue. A special permit to begin building was granted in 1976.

The well-known sportswriter William Oscar Johnson declared in the December 15, 1980, *Sports Illustrated* edition that Beaver Creek could be "the Last Resort." Coinciding with the opening day of Beaver Creek, the article described the challenging process of getting the resort built. He wrote the following: "But reaching this happy point involved such a long, painful, expensive, exhausting, frustrating process that sane men may well be discouraged from trying ever again to create something like Beaver Creek."

Indeed, Johnson could have summed up what the pioneers 100 years before had endured to squeeze out a life in this valley. Take Annie Holden, the young mother and wife who fell through a trapdoor in the hay barn to her death. Or there is the crash of the lettuce market in the 1930s, which forced families to sell their land and leave. A few settlers, like the Eatons, Offersons, and Nottinghams, thrived and stayed with the land, passing it on to their children to inherit.

Traces of Ute hunting camps in Beaver Creek provide a peek into another era of families enjoying what the land offered. Many people who helped shape Beaver Creek are gone or are not specifically mentioned in the book, but they are not forgotten. From the early homesteaders to the first ski lift operators, it took countless helping hands of dedicated folks to bring this world-class resort to what it is today.

History marches on bringing new families, industries, and events to this beautiful land. Enjoy the natural beauty that has been carefully preserved by the visionaries who first saw the recreational potential of this valley. This is a snapshot of the history of Beaver Creek, which will continue to grow for generations.

One

THE HOMESTEADERS

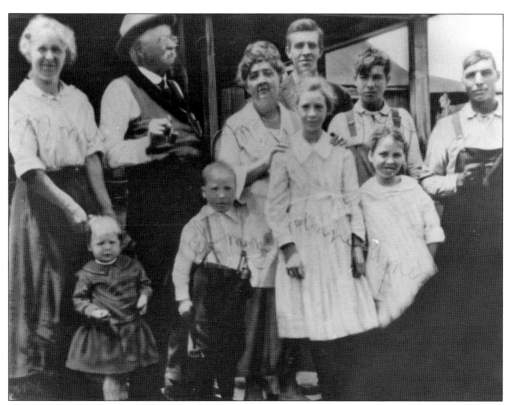

The Holden family moved from Washington State in 1912. They were of Scottish ancestry and developed a dairy farm in Beaver Creek. The young lady at far right is Agnes Holden. She attended school in Avon for eight years. In 1929, she married Harold Randall, had four children, and moved to Eagle, Colorado. (Courtesy of Eagle County Historical Society, Eagle Public Library.)

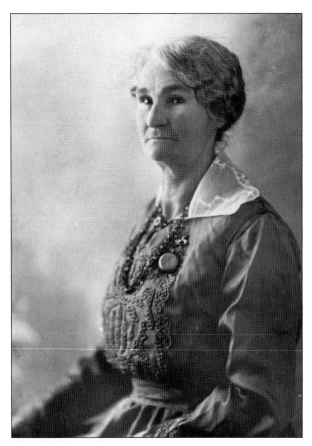

A pioneer husband and wife, Nancy Angeline and William Nottingham, are prominent in Avon history. William formed a business partnership with Ernest Hurd and Peter Puder. After four years, the partners were in debt. Business problems ultimately prompted Puder to commit suicide. Hurd, who was living with William and Nancy, accused Nottingham of frittering away the business. One day in 1896, after a quarrel with his wife, William chased Ernest into the barn loft in Red Cliff. A gunfight ensued, and William was killed. The court found Ernest innocent, ruling self-defense. Three years later, Ernest married Nancy Angeline, resulting in her new name Nancy Angeline Nottingham Hurd. Soon after he married Angeline, they bought Peter Puder's property. Ernest left to visit his family in Maine where he contracted small pox and died. (Both, courtesy of Eagle County Historical Society, Eagle Public Library.)

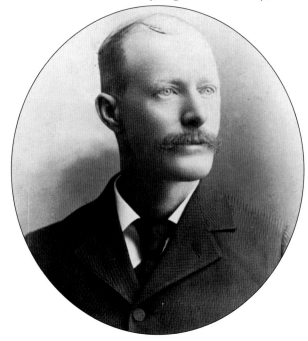

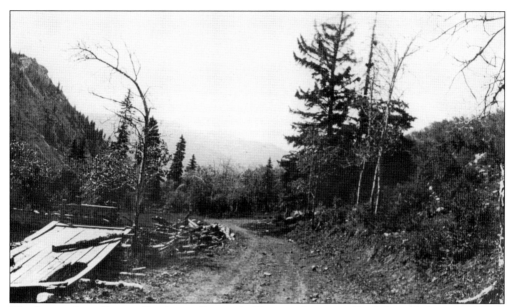

The first settler at Beaver Creek was George A. Townsend, a young Englishman who moved from Leadville, Colorado, between 1881 and 1882. According to the book *Avon: No Longer a Lettuce Patch*, Townsend grubstaked with friends Abijah Berry and Daniel Burnison by providing funds for adjacent land, ending up with 400 acres along Beaver Creek in 1889. This is a view of the original ranch, looking up the Beaver Creek valley, where Townsend raised beef cattle. (Courtesy of Eagle County Historical Society, Eagle Public Library.)

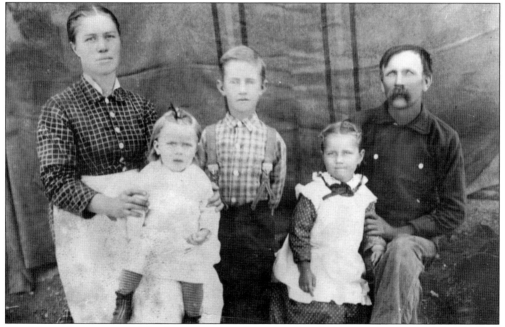

The Metcalfs were some of the first pioneers to homestead in the Beaver Creek area. They applied for land in 1884 under the Homestead Act. Pictured are, from left to right, Lizzy, Emma, John, Amy, and John C. Metcalf. Emma died of pneumonia just short of her 15th birthday and was buried in Edwards, Colorado. (Courtesy of Eagle County Historical Society, Eagle Public Library.)

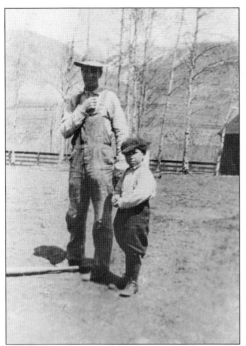

John Holden and son Jimmy are practicing baseball in the Avon schoolyard. John has a bat between his feet and a glove on his left hand. John, originally from Scotland, moved his five children and wife to their Beaver Creek ranch in 1917. Baseball was a popular pastime with the locals playing against neighboring teams in Minturn, Glenwood Springs, and Edwards. (Courtesy of Eagle County Historical Society, Eagle Public Library.)

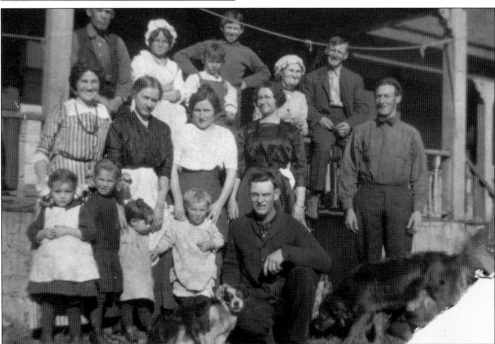

The Nottingham clan gathered on the porch in 1914. They raised cattle and sheep for many years on the original 1887 homestead in Avon. From left to right are (first row) Leota (daughter of Clyde), Winifred, Claire, Willis, and uncle Ed Sweeney; (second row) Lou Nottingham Sweeney, Marie Nottingham, Frances Nottingham, Myrtle Nottingham, and Harry Nottingham; (third row) George Clyde, Lola (his daughter), Bill Sweeney (son-in-law), Roland, grandmother Angeline Nottingham Hurd, and Emmett Nottingham. (Courtesy of Mauri Nottingham.)

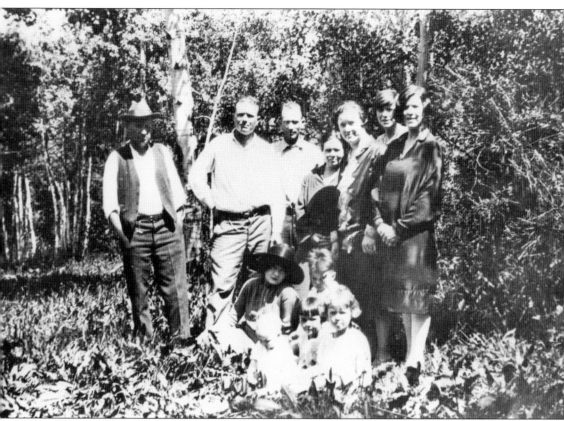

Pictured in 1923, the Rodgers and Hart families are enjoying a picnic in Beaver Creek. They are, from left to right, (first row) Roger Hart (baby), Grace Rogers, and Jean Hart; (second row) Mabelle Robertson and Bobby Hart; (third row) Claude Robertson, Ed Rodgers, Bill Hart, Mamie Rodgers, Bertha Robertson, Teddy Tolbey, and Annie Hart. Claude Robertson was the Avon depot agent with the D&RG Railroad. They migrated from Texas and farmed lettuce, peas, and potatoes in Beaver Creek and Bachelor Gulch. (Courtesy of Eagle County Historical Society, Eagle Public Library.)

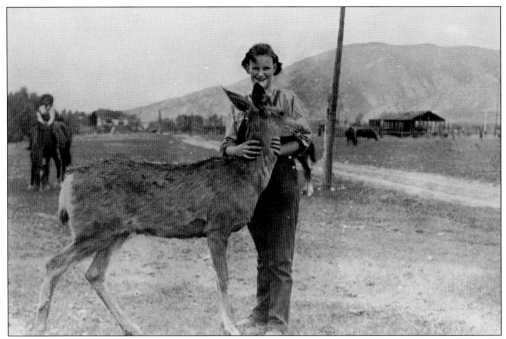

Willis Nottingham, grandson to original pioneer William, brought this baby deer home one day. He found its mother had died while tangled in a barb-wired fence. His sister Imogene is standing with the pet deer. In the right background stands one of three lettuce sheds. In the book *Bob-O's Turn in Avon*, author Bobby Hart recounts that the deer frequently rode in the Model T with the local kids. (Courtesy of Eagle County Historical Society, Eagle Public Library.)

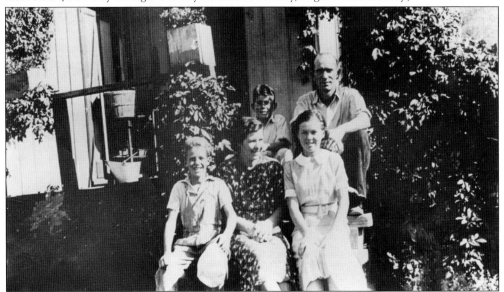

The Kelly Hart family is seen sitting in front of the Avon train depot. From left to right are (first row) Roger, his mother, Ann, and sister Jean; (second row) Bobby and his dad, Kelly. As told by Bobby Hart in his book *Bob-O's Turn in Avon*, his aunt Mrs. Claude Robertson was married to the depot agent and encouraged them to move from Texas to Avon, Colorado. (Courtesy of Eagle County Historical Society, Eagle Public Library.)

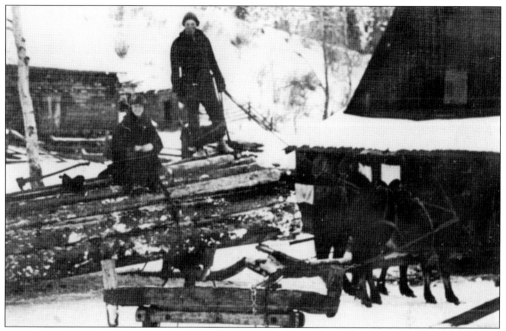

Mildred and Everett Howard are at their Bachelor Gulch home with a load of logs from McCoy Park. Mildred Bailey was a schoolteacher and met Everett through her students. Everett was introduced to Mildred under a hail of snowballs provided by the kids. They married in May when school ended. (Courtesy of Eagle County Historical Society, Eagle Public Library.)

On February 17, 1906, S.A. Bivans bought a general mercantile and meat establishment called the Avon store. It was a single-story log structure, and the family lived in the back. The original log structure shown in this c. 1950 photograph was moved around 1996; it is now located 30 miles west in the town of Eagle, as part of Eagle County Historical Society's museum complex. (Courtesy of Mauri Nottingham.)

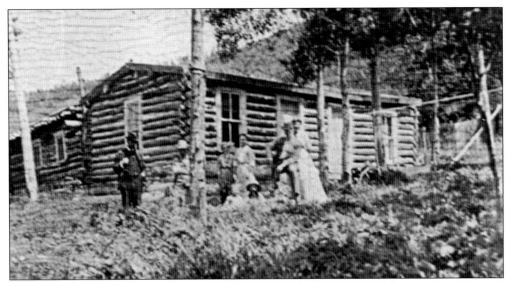

Originally from Scotland, John and Mary Thomas moved to Beaver Creek from Indiana. Records from the Eagle County assessor confirm that John Thomas acquired the land in 1909. Seated on the ground in front of their home are sons Charley and Cliff. Standing are, from left to right, unidentified, John Thomas, Mabel (daughter), Mary, an aunt, and uncle Tom Norris. About 66 years later, this property would be the base of Beaver Creek Resort. (Courtesy of Eagle County Historical Society, Eagle Public Library.)

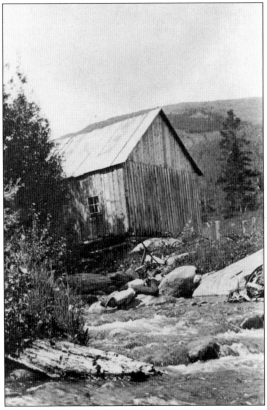

Mabel Thomas would marry Charles Eaton on January 24, 1920. They would take up residence at her family ranch. Here, Beaver Creek provides a refreshing drink for one of the Eatons' ranch hands. The man is balancing on a rock in the creek. Note the hay barn behind him. (Courtesy of Eagle County Historical Society, Eagle Public Library.)

High above Beaver Creek sit Tennessee and Beaver Lakes. Lumber was abundant around Beaver Lake. Large lumber companies from Leadville and Red Cliff cut trees for building mines and general construction. The Fleming Lumber and Mercantile Company location in Red Cliff is shown here in January 1926. A few months later, four lumber companies merged, naming J.F. Fleming as vice president. (Courtesy of Eagle County Historical Society, Eagle Public Library.)

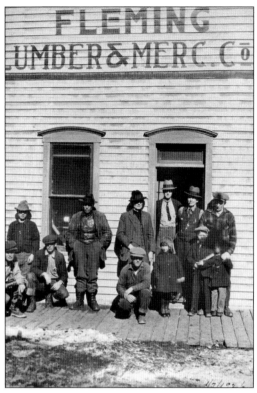

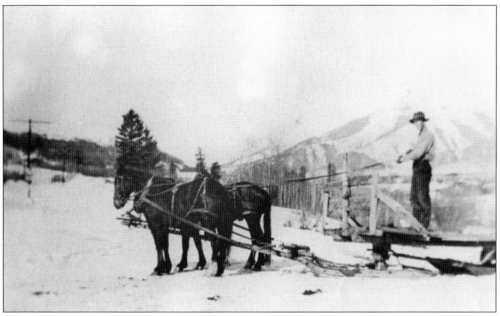

Logging was a year-round endeavor. In winter, cutters would dig out the snow to get as much of the tree exposed as possible. The logs would be chained together and pulled by horses to flat railroad cars in Avon. Everett Howard is seen holding the reins of his horse team after unloading logs. The Howards logged in the winter to support themselves. (Courtesy of Eagle County Historical Society, Eagle Public Library.)

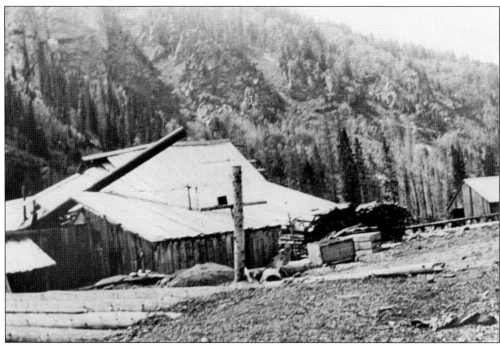

From the late 1880s to the early 1920s, lumber was an important part of Beaver Creek commerce. The loggers harvested on part of the mountain known as Baldy and McCoy Park. In summer, logs were pushed down a chute into the lake, then floated to the outlet, picked up, and run through this sawmill at Beaver Lake. Around World War I, logging was curtailed. (Courtesy of Eagle County Historical Society, Eagle Public Library.)

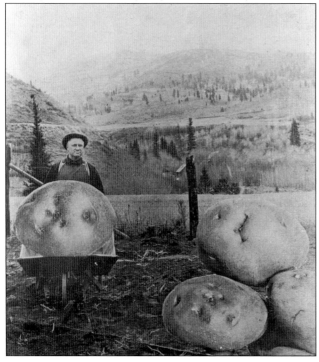

During the summer, homesteaders' livelihood was agriculture. Gulling Offerson promotes the 1902 Beaver Creek potato harvest in this photograph. The superimposed potatoes are displayed with flair to attract customers. Early settlers maintained a sense of humor in spite of enduring harsh weather, hard work, and adversity to feed their families. (Courtesy of Eagle County Historical Society, Eagle Public Library.)

Two

SALAD DAYS ARRIVE

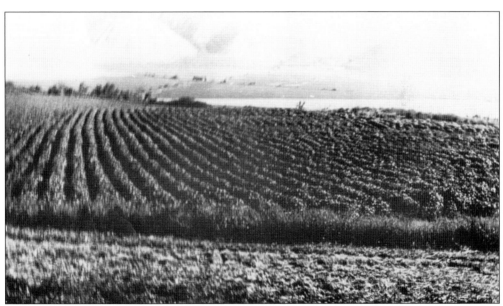

From 1900 through the 1920s, potatoes remained one of the three strongest cash crops, followed by lettuce and peas. Rows upon rows of spuds are seen here on the Offerson Ranch in 1929. Gulling Offerson was a prominent citizen of Beaver Creek and was county commissioner for many years. He bought the original homesteads of George A. Townsend, Burnison, and Berry. (Courtesy of Eagle County Historical Society, Eagle Public Library.)

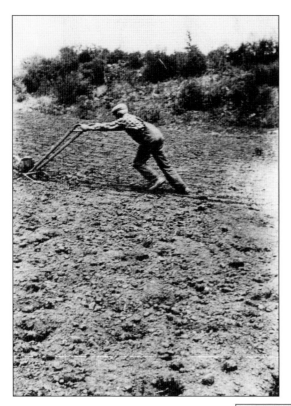

The lettuce boom started in the 1920s. Valley farmers, especially those in the Bachelor Gulch area, began planting head lettuce. John Bunker pushes a lettuce planter on the Offerson Ranch. Lettuce thrived in the climate and mountain soils, grew quickly, and tasted particularly crisp. The lettuce was just ready to be shipped when lettuce disappeared in groceries in other parts of the country because their growing season had ended. (Courtesy of Eagle County Historical Society, Eagle Public Library.)

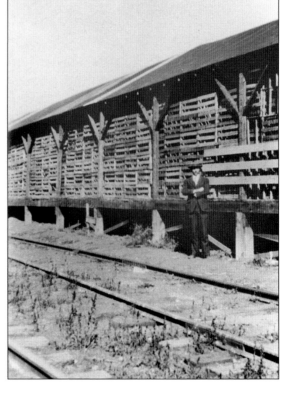

A gentleman stands dressed in a suit and tie in front of one of three lettuce sheds on the east railway spur of the Avon depot. Colorado lettuce was ready to ship from around July 15 to October 15. Once the harvest was finished, the companies who managed the sheds would move on to another area of the state. The photograph here shows a date of October 15, 1928. (Courtesy of Eagle County Historical Society, Eagle Public Library.)

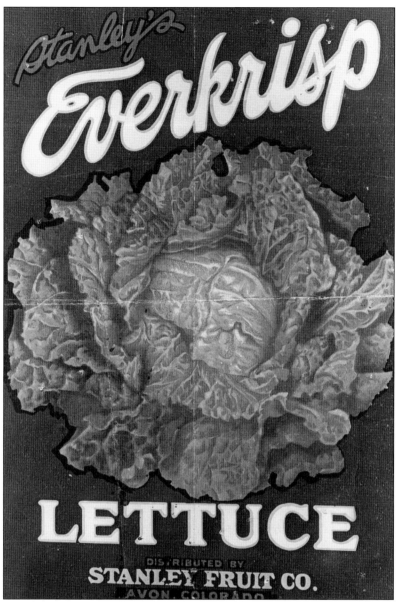

In July 1926, the Stanley Fruit Company of Phoenix, Arizona, shipped the first carload of lettuce from the Denver & Rio Grande Railroad's Avon depot. The Everkrisp Lettuce crate label promoted the crispy lettuce qualities the people in the eastern part of the United States were seeking. Early in April 1927, experts set a statewide production goal of $1.5 million for the lettuce crop. This was a half a million dollars higher net to growers than the year prior. According to the *Eagle Valley Enterprise* newspaper of April 22, 1927, "A high-altitude demonstration train, outfitted by the horticultural department of the Colorado Agricultural College was to arrive in Avon on April 25. Colorado has an enormous marketing advantage in the flavor of the mountain-grown crops, but this advantage was too frequently lost by careless handling. Two factors working to the disadvantage of local growers were "pack and yield." Better growing practices and more careful packing should result in a fifty percent increase in revenue, asserted E.F. McKune federal-state inspection supervisor." (Courtesy of Eagle County Historical Society, Eagle Public Library.)

Local residents gathered at the Avon Amusement Center for dances, ice cream socials, and entertainment. The landmark Gypsum Cliffs are in the background with the Avon Amusement Center on the left side of Highway 6. When Highway 6 was widened in 1948, the building was destroyed. (Courtesy of Eagle County Historical Society, Eagle Public Library.)

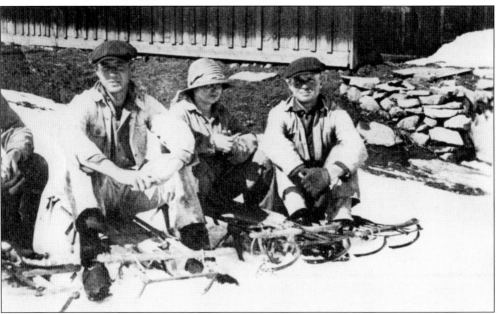

Rufus Rodgers, nicknamed "Uncle Doc"; Mamie; and husband Ed Rodgers are on their sleds in the winter. A 1975 interview with Grace White, daughter of Ed Rodgers, related what occurred this day. The boys went off sledding and left Mamie behind. She was on a short sled that would go "whoo!" down through the snow, and she got stuck. Mamie was so angry that she cried. The boys went back to dig out the sled. (Courtesy of Eagle County Historical Society, Eagle Public Library.)

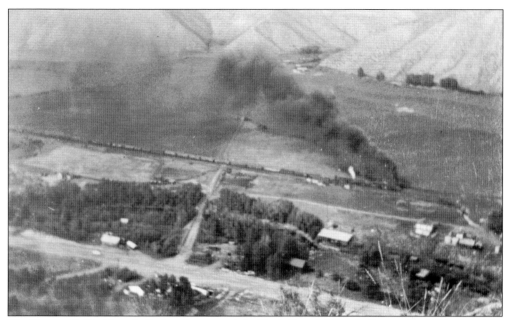

The Denver & Rio Grande Railroad traversed the Eagle River Valley. In September 1921, according to the *Eagle Valley Enterprise*, fireman White was working when a stray bullet in the cab of the locomotive hit him. His engineer saw him fall to the floor and quickly stopped the train in Avon. A doctor was called, and he was transferred to the railroad hospital in Salida. The outcome of his injuries is unknown. (Courtesy of Mauri Nottingham.)

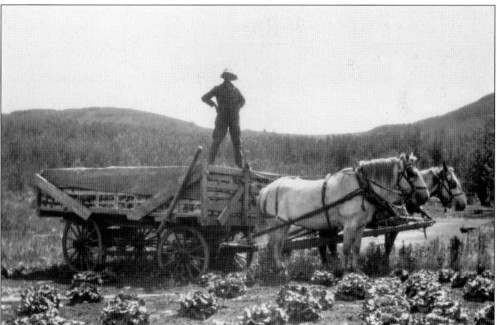

Johnny, son of William and Nettie Eaton, is seen standing on a lettuce wagon in Bachelor Gulch around 1918. Aided by his horses Prince and Dolly, he would venture down to the lettuce sheds railroad side at the Avon depot. The Eatons lived at McCoy Ranch, which would become Arrowhead at Vail. (Courtesy of Denver Public Library, Western History Collection [WH1605.])

Bachelor Gulch is west of the Beaver Creek valley. The origin of the name, perchance, came from the fact the men who settled here in the early days were all bachelors. The bachelors were an animated bunch. Eventually, the bachelors moved on. A resident of the area, Everett Howard ran the ranch for his dad, John. This is one of the Howard barns in Bachelor Gulch. (Courtesy of Mauri Nottingham.)

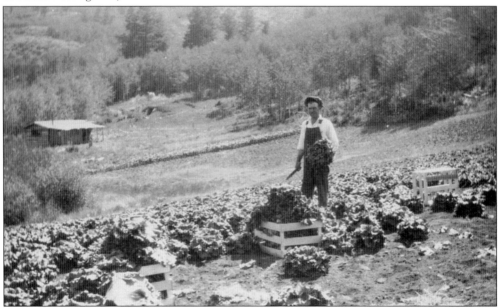

McCoy Ranch was Vernon and Zelma Eaton Mann's lettuce land on Terrill Creek. Located on the west side of what is now known as Arrowhead, the Manns would return to the property in the summer. During the winter, they resided in Nebraska. Her brother Johnny Eaton is harvesting lettuce in Bachelor Gulch in the area of Gunders Run. (Courtesy of Denver Public Library, Western History Collection [WH1605.])

Three

LAYING DOWN ROOTS

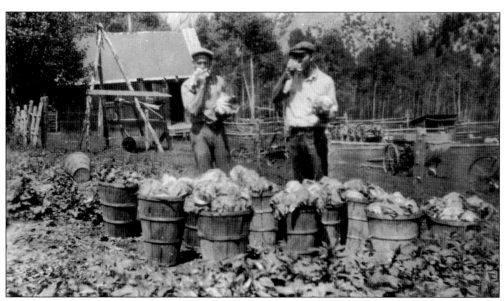

The lettuce boom ended in the mid-1930s as a result of poor cultivation, shipping practices, and economic challenges. Originally, lettuce would garner up to $5 a crate; however, toward the end, the farmers would be lucky to receive $1 per crate. (Courtesy of Denver Public Library, Western History Collection [WH1605.]

By the end of the 1930s, agriculture went into planting hay fields to support the cattle, horses, and sheep in the area. Sheep resulted in two or three cash crops per year. But when the Depression arrived, it forced smaller farmers out of business. At that time, Gulling Offerson and W. Emmett Nottingham began buying and consolidating ranches in Beaver Creek and Bachelor Gulch. (Courtesy of Vail Resorts, Inc.)

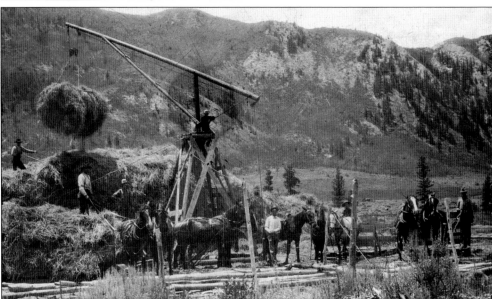

Local folks referred to this hay stacker as a Mormon derrick. Men with their team of horses are lined up waiting for hay to be put in their wagons. Successful ranchers invested in cattle, sheep, and horses and found that the land was well suited to grow hay to feed the livestock. (Courtesy of Mauri Nottingham.)

The SBAH ditch was named for homesteaders Spaulding, Borders, Anderson, and Howard. The ditch delivered water from Beaver Creek around the ridge into Bachelor Gulch and was the irrigation system. Bobby Hart, a youngster living up Bachelor Gulch, was hired to keep the ditch free of debris and flowing. He once pulled a gate to let water out, causing a flood that resulted in severe erosion. From that point on, he was called "Mud." (Courtesy of Denver Public Library, Western History Collection [WH1605.])

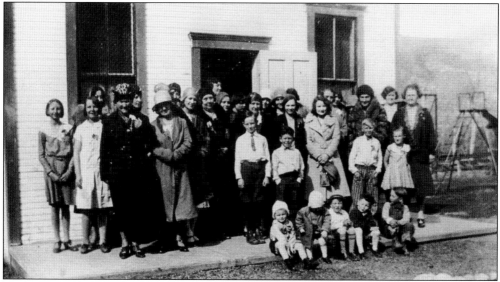

Teachers and students of Avon School are seen in 1933. Pictured are, from left to right, (first row) children Charlotte Nottingham, Maurice Nottingham, unidentified, Frances Walsh, and unidentified; (second row) Vincent Walsh (the young boy wearing the tie), Bobby Hart, Maybelle Robertson, Stanley Gustafson, and Immogene Nottingham. Standing behind the two rows of younger children are, in various order, Carol Nottingham, Elizabeth Holden, a Mrs. Evanick, Annie Holden, Helen Brown, Winifred Nottingham, and Marie Nottingham. (Courtesy of Mauri Nottingham.)

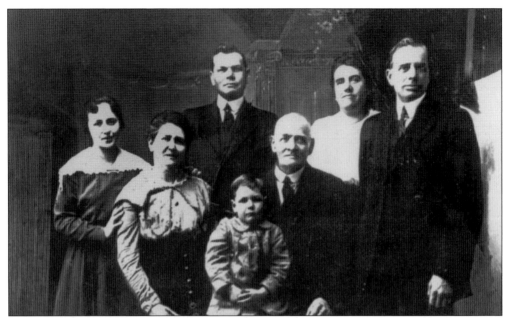

Gulling Offerson and his family travelled to Seattle, Washington, for a visit. Pictured are, from left to right, (first row) Austin Offerson; (second row) grandmother Christiania and grandfather William Offerson; (third row) unidentified; Gulling Offerson; Gulling Offerson's wife, Olive; and George Porter. Gulling died in a tragic car accident in 1941 just east of Beaver Creek. His son Austin struggled to keep the ranch operating. (Courtesy of Mauri Nottingham.)

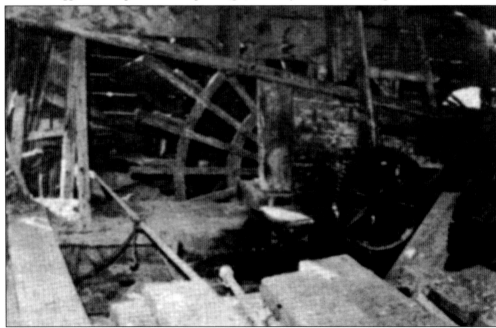

Clyde, Harry, and Emmett Nottingham were brothers. All three ranched in the Eagle River Valley. Clyde Nottingham built the waterwheel to generate power for his ranch, and it provided power to the Avon depot. The ranch was located east of the Beaver Creek and Eagle River confluence. Remnants of this waterwheel still exist on the Eagle River. (Courtesy of Mauri Nottingham.)

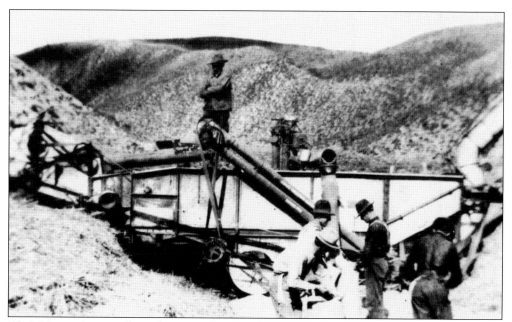

Clyde Nottingham works with a crew of men as they bag grain. Clyde was a bit of a crusty fellow. After appearing before the judge in Eagle County on numerous occasions, Clyde was given an ultimatum. Either Clyde was to serve jail time for his wrongdoings or he had to leave the county. Nottingham and his family moved to Glenwood Springs, 40 miles west of Avon. (Courtesy of Mauri Nottingham.)

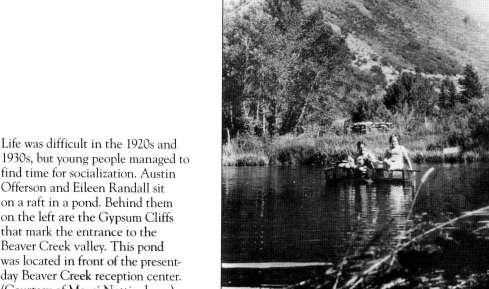

Life was difficult in the 1920s and 1930s, but young people managed to find time for socialization. Austin Offerson and Eileen Randall sit on a raft in a pond. Behind them on the left are the Gypsum Cliffs that mark the entrance to the Beaver Creek valley. This pond was located in front of the present-day Beaver Creek reception center. (Courtesy of Mauri Nottingham.)

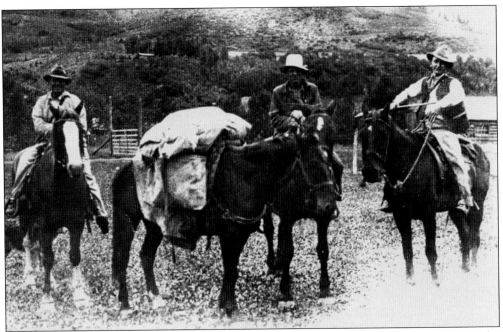

Fishing was a popular sport for the locals. This group is packed up for a multiday trip into the mountains. Fishing was good up at high mountain lakes, such as Piney Lake. The trip would lead them into mountain lion and bear territory making the rifle held by the man on the right a necessity. (Courtesy of Mauri Nottingham.)

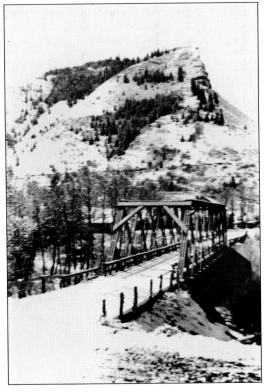

This is the second bridge constructed around 1923 to connect Avon with the Beaver Creek valley. Below the bridge is the Eagle River where kids would ice-skate in the winter or folks would fish in the summer. In the left background are the Gypsum Cliffs rising above the Beaver Creek valley floor. (Courtesy of Mauri Nottingham.)

In 1948, Harry and Marie Nottingham bought the college farm property. The college farm was an experimental agricultural operation established by the state agricultural college—Colorado A&M—in Fort Collins. Their children Alan and Winifred are standing in front of the house around 1951. Winifred Nottingham Mason recalled the history of the property in a 1990 newspaper article. Originally, a family from Denver by the name of Stone owned the property, which was located about three miles east of Avon (in what is now Eagle-Vail). The Andersons were hired to be caretakers, as the Stones only visited on weekends or holidays. Gulling Offerson, a successful rancher, bought the property and then sold it to the Colorado A&M of Fort Collins between 1930 and 1935. Students and technicians would come to the farm to oversee various agricultural experiments. Results from the projects would then be publicized in periodicals and college literature. The lettuce growers in the area then received information on improved horticultural practices. (Courtesy of Eagle County Historical Society, Eagle Public Library.)

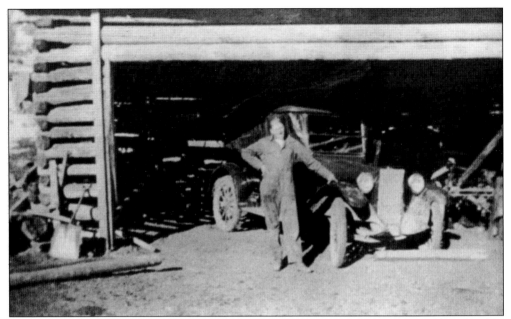

Times were changing for the hardworking folks in Bachelor Gulch. Everett Howard kept his first car, a Dodge, in his log barn in Bachelor Gulch. The car made traveling around the area much easier. Everett is dressed in overalls, apparently taking a break from working the lettuce fields. Everett and his wife, Mildred, loved to dance. The *Eagle County Blade* newspaper often reported their attendance at dances. (Courtesy of Mauri Nottingham.)

This photograph was taken looking up Beaver Creek valley in late fall before Willis Nottingham sold his property in August 1972. McCoy Peak stands majestically in the background. After the lettuce boom of the 1930s, the land was planted with hay to support ranchers' livestock. Cattle and sheep graze in the hay meadow that eventually would be home of the Centennial chairlift. (Courtesy of Vail Resorts, Inc.)

Four

UP A CRICK
WITHOUT A PERMIT

A road through the Willis Nottingham ranch leads to the mountain where the proposed ski area, Beaver Creek, would be built. In 1970, the 1976 Winter Olympics were awarded to Colorado. Beaver Creek was to host the Alpine ski events; however, Colorado declined the honor to host the Winter Games with the defeat of the bonds in the November 1972 statewide election. Nottingham sold 2,200 acres to Vail Associates in 1972. (Courtesy of Vail Resorts, Inc.)

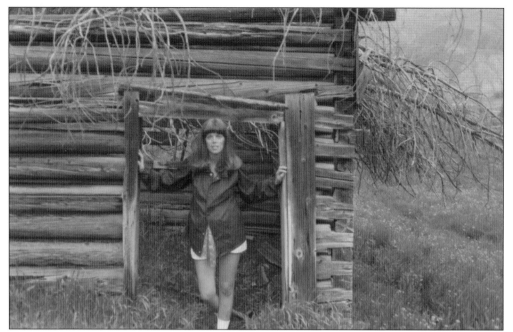

Dandelions and green grass evoke signs of summer in this mid-1970s picture. While exploring the beautiful valley, Lauretta Purcell poses in the doorway of the Thomas homestead. Originally, the homestead was deeded to John Thomas and his family in 1909. This building would be one of several moved or restored before resort construction began. (Courtesy of Sandy Smith.)

Dee Brown in her yellow down vest was caught on camera frolicking in front of a historic barn. She is with friends on a cross-country ski tour toward the proposed Beaver Creek ski area in the winter of 1976. Wooden ski, poles, jeans, and low-cut boots were sufficient equipment at that time. (Courtesy of Sandy Smith.)

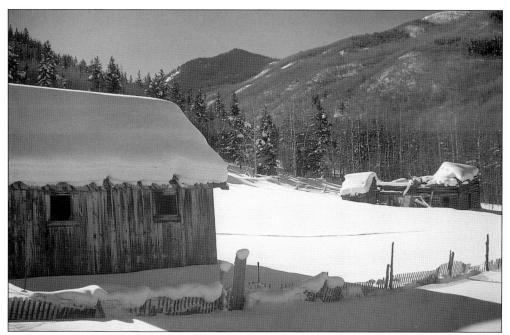

Here is a picturesque hay meadow in winter. The collapsing homestead on the right belonged to the Thomas family. Earl Eaton reportedly skied this area in the spring of 1956. He found it steeper than nearby mountains with impressive views of the Gore and Sawatch ranges. Snowfall was consistent, making this an ideal location for a ski area. (Courtesy of Vail Resorts, Inc.)

Here, longtime Vail locals Sandy Smith, John Horvath, and Randy Sundblad are relaxing next to the Holden barn in Beaver Creek. Mild temperatures and corn snow in the spring of 1975 enticed them to cross-country ski up the valley. Joan Horvath took the photograph and then prepared a picnic spread complete with libations. Through the back window of the barn, one catches a glimpse of the Gypsum Cliffs near Avon. (Courtesy of Sandy Smith.)

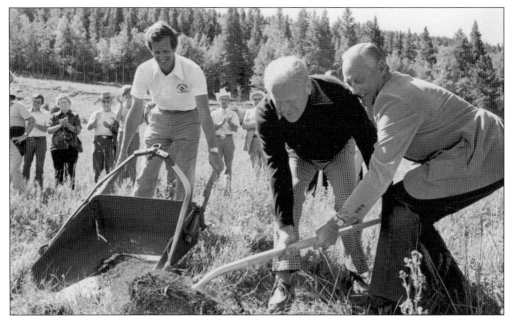

Here, onlookers celebrate at the ground-breaking ceremony for Beaver Creek on July 20, 1977. From left to right are Jack Marshall, president of Vail Associates; former US president Gerald Ford; and Harry Bass, chairman of Vail Associates. Local county commissioners, the Forest Service, and Governor Lamm's office had to submit approval of Beaver Creek before construction could begin. It took years to receive all the necessary approvals. (Courtesy of Vail Resorts, Inc.)

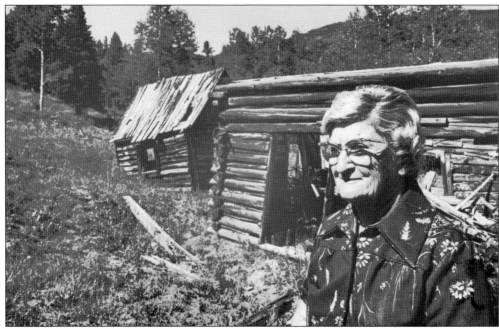

Mabel Thomas Eaton is standing in front of her family homestead, which was built around 1910. She attended the ground-breaking ceremony in Beaver Creek. Her husband, Charley Eaton, attended the ceremonies with her. Charley's nephew Earl Eaton first skied the area and encouraged the ultimate development of Beaver Creek. (Courtesy of Vail Resorts, Inc.)

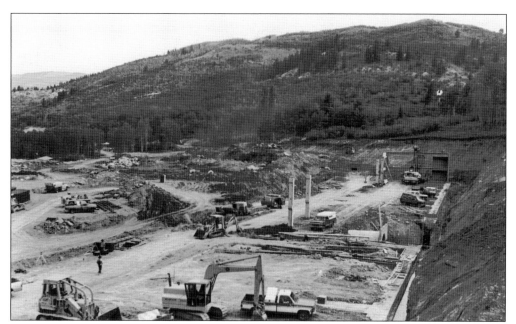

An underground parking structure, which was to be located under Village Hall, is being excavated in this picture. This was one of the first projects that needed to be completed for the opening of the ski area. Vail Associates required all engineers and subcontractors to attend regular meetings with project architect Jack Zehren and his team to ensure projects had a consistent look. (Courtesy of Vail Resorts, Inc.)

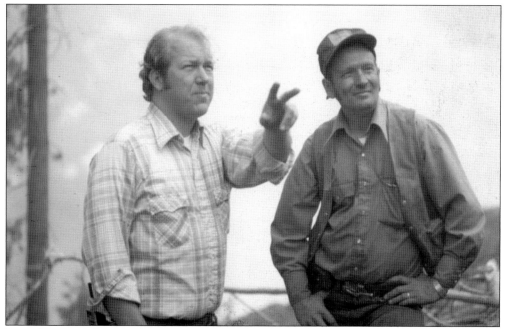

Roger Lessman, director of Mountain Operations, confers with an unidentified logger on design of ski runs early in the project. Lessman was responsible for the building of trails and lifts on Beaver Creek Mountain. According to Lessman, "Calling off the Olympics was good for Beaver Creek Development. It would not have been what it is today." (Courtesy of Vail Resorts, Inc.)

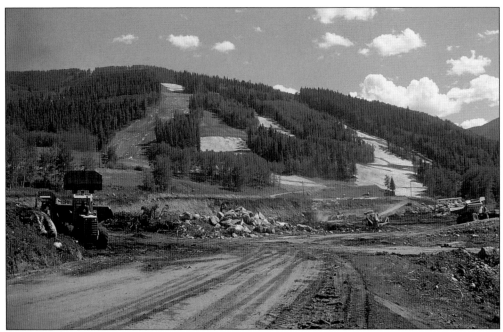

Marvin Gray operated heavy equipment during the construction of Beaver Creek. He was featured in *The Craftsmen of Beaver Creek* brochure that the company put together in the late 1970s. Gray once stated, "How many people can say they were there when it all started, helping to build it. I'm excited about what we are accomplishing here." (Courtesy of Vail Resorts, Inc.)

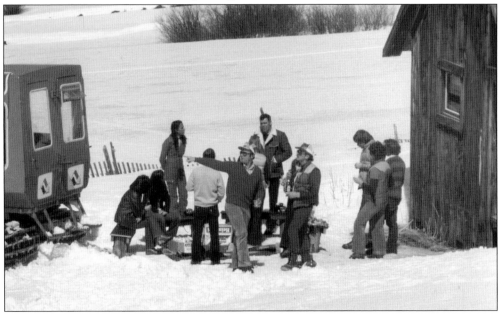

Before Beaver Creek opened, Pete Seibert, seen pointing in the foreground, brought celebrities, ski writers, and famous skiers to the area for snowcat tours. A picnic lunch was included at the "Seibert hotel," the historic barn on the right. Mike Larson, part of the trail planning crew, often drove the IMP. Manufactured by Thiocol, the IMP was a smaller version of the full-size grooming snowcats. (Courtesy of Vail Resorts, Inc.)

Pete Siebert, an excellent salesman, relished sharing his dream of Beaver Creek. Clowning around, he would grab some oranges and share his juggling skills with clients. He spent his life skiing; his goal was to develop a ski experience commonly found in Europe. Seibert envisioned skiing village to village from Vail Mountain to Beaver Creek and beyond. (Courtesy of Mike Larson.)

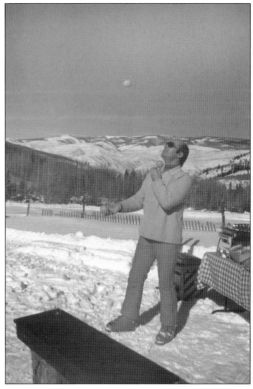

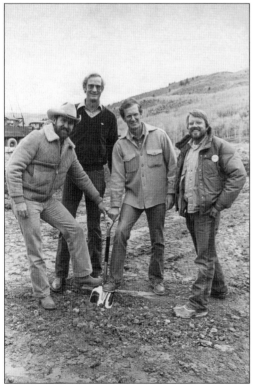

Big smiles are seen all around for the Poste Montane Lodge ground breaking. From left to right are Brian Rapp, president of Beaver Creek Resort Company; Charlie Gardner, executive vice president of Beaver Creek Development Company; Jack Marshall, president of Vail Associates; and Dean Kerkling, head of trail planning. The Poste Montane would encounter financial difficulties, stalling development, but would overcome them to open in 1984. (Courtesy of Vail Resorts, Inc.)

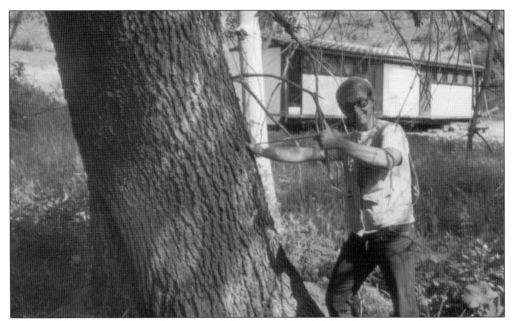

Duke Hall was environmental coordinator for Beaver Creek. His job was to minimize the impact on the valley and mountains by construction crews. He explained in *The Craftsmen of Beaver Creek* that "some of those trees have been here since before the American Revolution. You think twice before you determine whether it's necessary to cut one of those down or not." Hall is seen boring a spruce in July 1979. (Courtesy of Cliff Simonton.)

"One of a kind" was how Bob McIlveen, a former colleague, described Larry Litchliter. Hired as controller in Vail for Vail Associates, he was sent over to Beaver Creek when they began construction. Although he came from the finance side, Larry had a penchant for operations. Eventually, "Litch," as he was known, became vice president of operations for Vail and Beaver Creek Resorts. (Courtesy of Dann Coffey.)

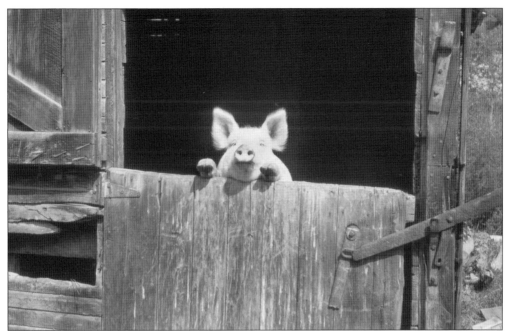

"That's all for Nov. '79 folks." Meet Samantha the pig, who belonged to the Motts. In the middle of winter, they had to bring her into their kitchen to deliver her litter of piglets. During the construction of Beaver Creek, the Mott family lived at the entrance to the resort. (Courtesy of Cliff Simonton.)

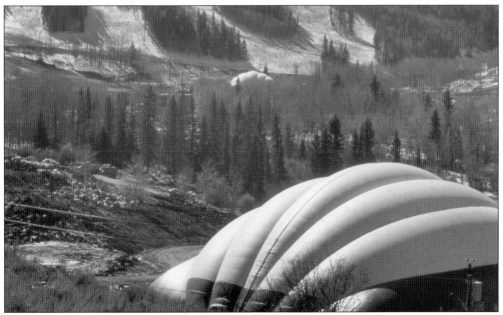

As the saying goes, never judge a book by its cover. This applies to the charter at the Beaver Creek sales office. Model units housed in this unpretentious bubble were priced in the six-figure range. The developer needed to enhance the decor for prospective buyers. One improvement included a carved-wood antique back bar where clients could be entertained during a sales presentation. (Courtesy of Cliff Simonton.)

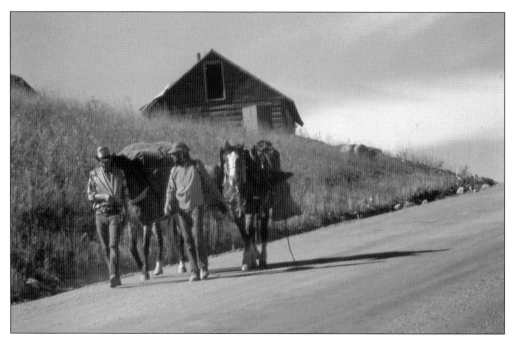

Two hunters lead packhorses out of their Beaver Creek hunting camp in the fall of 1980. Hunting elk and deer in the area dates back to the time Ute Indians inhabited the area. Today, the tradition of seeking big game continues in this section of the Eagle River Valley. (Courtesy of Cliff Simonton.)

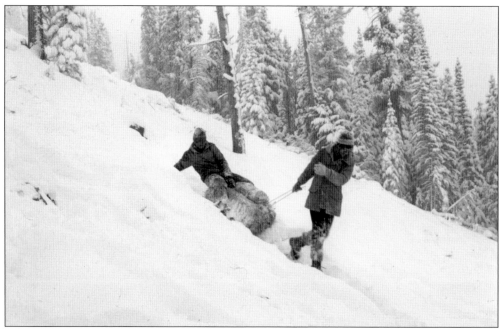

Crews scrambled to get lift towers ready for the December 1980 opening. An early October snowstorm helped transport bags of grout down to lift towers that needed to be set. Here, two lift crew members maneuver a bale of straw under Chair No. 9, as though swooshing through the snow on a sled. (Courtesy of Dann Coffey.)

Bob Parker was senior vice president of operations when he steered Beaver Creek through the lengthy application and approval process. A large part of the concerns by the State of Colorado, Forest Service, and Eagle County commissioners focused on impact to the environment. As part of the tree protection process, Vail Associates implemented a $1,500 penalty on any construction worker who inadvertently cut down trees not approved for removal. (Courtesy of Cliff Simonton.)

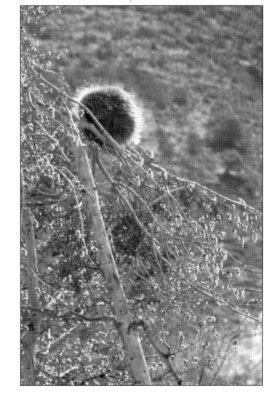

Capturing a porcupine curled up in an aspen tree is rare. The Latin name translates to "quill pig," according to *National Geographic*. It is the prickliest of rodents and spends much of its time up in trees. Shooting their quills is a fallacy; however, their quills do detach easily if touched, which often happens when dogs sniff them. (Courtesy of Cliff Simonton.)

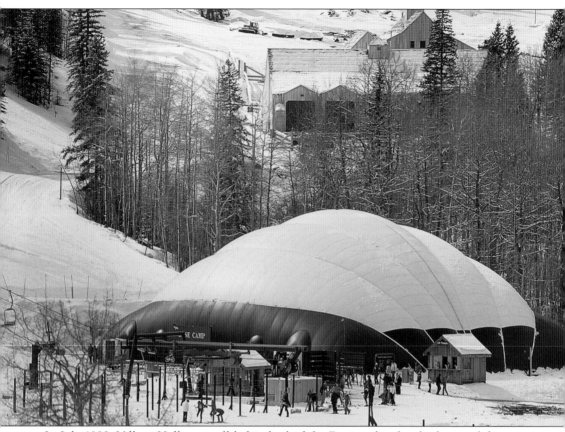

In July 1980, Village Hall was well behind schedule. Designed to be the heart of the resort, Village Hall would feature ski rentals, ski school, food service, bathrooms, and offices. Roger Lessman knew there was no way it would be completed in time for the December opening of the mountain. Driving to Denver one day, he noticed the Vail Racquet Club in east Vail had a tennis bubble. Manufactured by Bird-Air, the nation's most recognized fabricator of membrane structures, Lessman experienced an aha moment, acquired a catalog, and bought a bubble for $85,000. Bob Dorf, director of ski school, and David Adeen, director of food service, were put in charge of erecting the structure, getting power to it, and building a foundation. Inside featured a cafeteria, ski school, ski rentals, and a bar for après-ski gatherings. Outside was the ticket office in a modest wooden structure. (Courtesy of Vail Resorts, Inc.)

Five

OPEN AT LAST

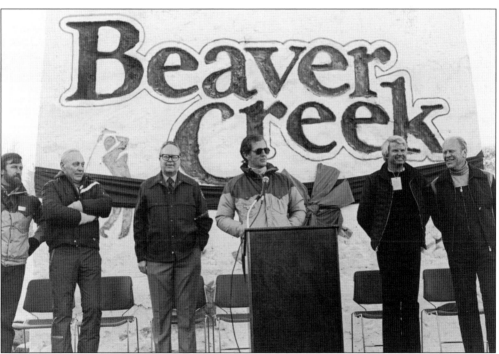

On December 15, 1980, Beaver Creek opened to the sound of champagne corks popping and muffled ski glove clapping as described in *Mountain Vision: The Making of Beaver Creek*. Opening ceremonies included, from left to right, Brian Rapp, president of Beaver Creek Resort Company; Harry Bass, chairman of Vail Associates; unidentified Forest Service representative; Jack Marshall, president Vail Associates; then governor Dick Lamm; and former US president Gerald Ford. (Courtesy of Vail Resorts, Inc.)

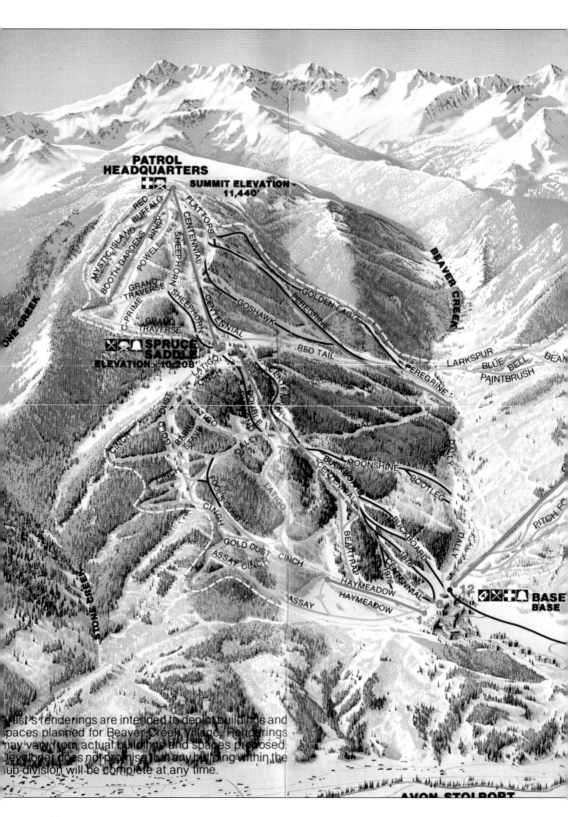

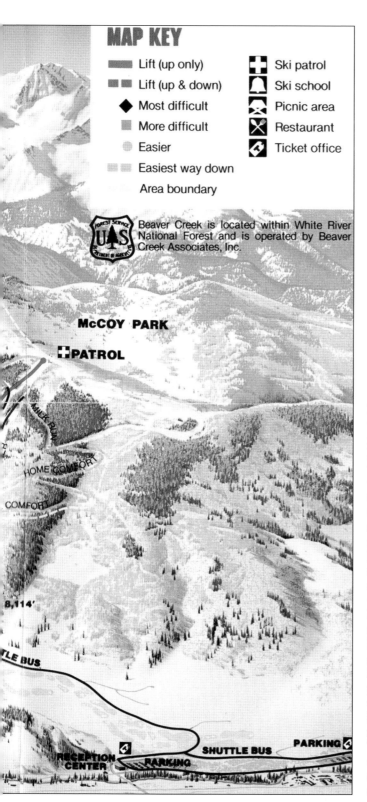

MAP KEY

▬▬▬	Lift (up only)	✚	Ski patrol
▬ ▬ ▬	Lift (up & down)	🔔	Ski school
◆	Most difficult	✕	Picnic area
■	More difficult	✕	Restaurant
●	Easier	◢	Ticket office
▬ ▬ ▬	Easiest way down		
	Area boundary		

Beaver Creek is located within White River National Forest and is operated by Beaver Creek Associates, Inc.

McCOY PARK

✚ PATROL

KINIK RUN

HOME COMFORT

COMFORT

8,114'

TLE BUS

◢ SHUTTLE BUS PARKING ◢

RECEPTION CENTER PARKING

Dean Kerkling was a former trail cutter and assistant mountain planner at Vail. He was given the task of writing the master plan for the ski mountain in Beaver Creek. One of his goals was to design a ski mountain that offered skiers an experience that emphasized the natural beauty of the area. In addition, he wanted to use construction methods that were ecologically sound. He discovered a new visual resource technique developed by the Forest Service. It was a computer program called Perspective Plot. Using this program, he was able to see what proposed trails looked like and change them if they did not appear skier friendly. The ski mountain opened with six chairlifts and 450 skiable acres. (Courtesy of Vail Resorts, Inc.)

47

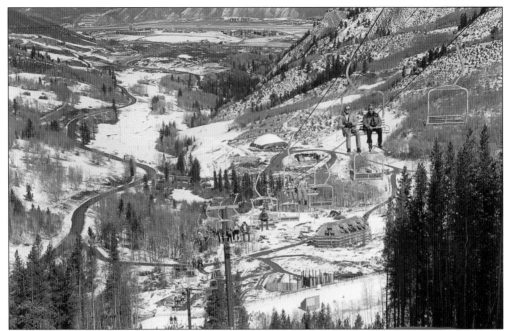

Reminiscent of Vail Mountain's December opening in 1962, Beaver Creek experienced light snow cover. Folks were excited to ski the new area albeit still in its infancy. Chair No. 6 is filled with skiers headed toward the top of the mountain on that first day. The winter that Beaver Creek opened, 1980–1981, only 122 inches of snow fell. (Courtesy of Vail Resorts, Inc.)

Bob Dorf (left) and Chris Ryman are riding a "snow whale" near the bottom of Chair No. 6 in the Haymeadow. During the snowmaking process, snow is piled up in large whale-shaped mounds. These dune-like shapes are then spread on the ski run in a soft skiable layer with the assistance of a machine with a blade referred to as a snowcat. (Courtesy of Bob Dorf.)

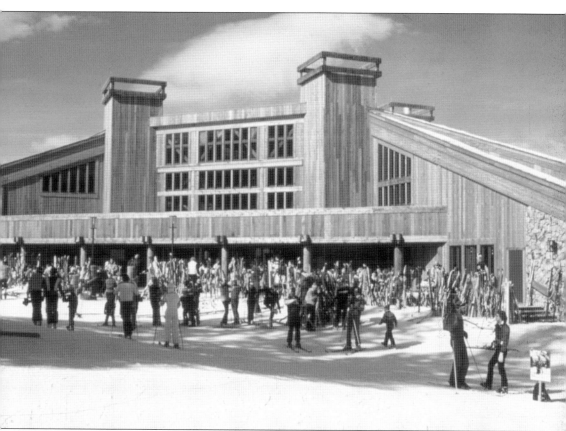

Spruce Saddle was designed by Bull Stockwell Allen Architects to be built with peeled logs and fieldstone. Heading up the Vail office, Sherwood Stockwell's vision was to use the fir timber coming off the mountain and all the bountiful rock that was a result of all the construction. This was projected to be one of the first green buildings in Colorado. As detailed in *When the Lions Come: Surviving the Architectural Jungle* by Sherwood Stockwell, being green would not be possible as the local building inspector would not accept any log used as a post without a structural stamp. The Forest Service input included the comment "and use of native rock would cause a depletion of natural resources." Both the timber and rock would be brought in from other states. Spruce Saddle Lodge was designed by Bull Stockwell Allen Architects and was given the Grand Award by the Pacific Coast Builders Conference/*Builders* magazine in 1981. (Courtesy of Vail Resorts, Inc.)

K2, a leading manufacturer of ski equipment in the United States, hired professional representatives at Beaver Creek. Although not paid, professional representatives skied on K2 skis thereby exposing products to instructors and customers. They showed others that the only way to ski well was by using K2 skis. Pictured are, from left to right, Bob Dorf, director of ski school; Dick McNamara, national K2 sales manager; and Joel Fritz K2, professional representative. (Courtesy of Bob Dorf.)

The inaugural ski school staff for the 1980–1981 ski season is pictured. Of the 20 instructors, 17 are identified: Bob Dorf, Jens Husted, Lynn Johnson, Suzanne Wibby, Larry Castruita, King Moore, Jamie Gainsboro, Christy Smith, Chris Ryman, Jimmy McIntosh, Kate Wasson, Carl Dietz, Tom Bassett, Robin Roberts, John Roland, Andy Johnson, and Wendy Von Almon. (Courtesy of Bob Dorf.)

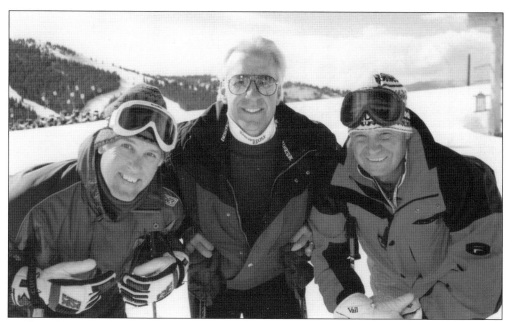

Leading the ski school were, from left to right, Jens Husted, Bob Dorf, and Chris Ryman. The first few seasons at Beaver Creek, the instructors often outnumbered their students. Beaver Creek was a great place to ski, providing an intimate experience with nature. Thirty years later, Husted, Dorf, and Ryman skied together during the 30th anniversary celebration of Beaver Creek. (Courtesy of Bob Dorf.)

Just weeks before the December 1980 opening of Beaver Creek Resort, crews were scrambling to finish the interior of Spruce Saddle Lodge. Sitting two-thirds of the way up the mountain, this was the only finished, permanent structure for the opening season. Spruce Saddle provided food service, restrooms, and a retail ski accessory shop. (Courtesy of Cliff Simonton.)

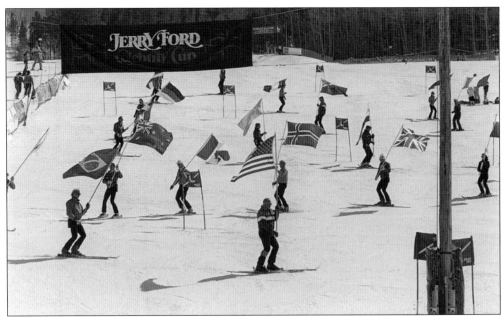

Former president Jerry Ford combined his love of skiing with a fundraising event. The Jerry Ford Celebrity Cup ski race was created and held in Beaver Creek as the premier event in 1980–1981. Each team that year paired a retired professional skier with a team of four celebrities, ranging in skiing ability from experienced to beginner. Vail Valley Hospital was the recipient of the money raised. (Courtesy of Vail Resorts, Inc.)

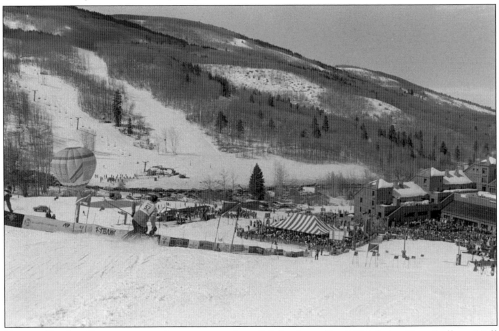

Beaver Creek village continued to grow, and so did the Jerry Ford Celebrity Cup. Village Hall was completed, anchoring the ski village. This is a bird's-eye view from the racecourse with spectators crowding the base area. American Express was a major sponsor and has an anchored hot-air balloon to the left of the racecourse. (Courtesy of Vail Resorts, Inc.)

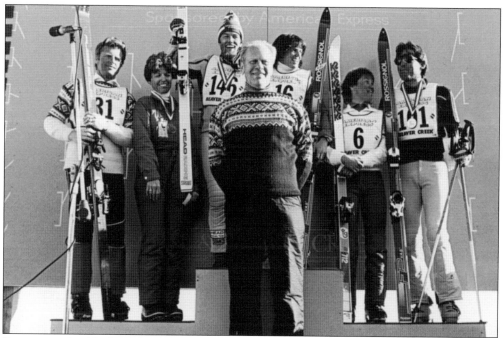

Former president Ford stands on the podium with the medal winners of the Jerry Ford Celebrity Cup. Over the years, the event would grow to include World Cup events, evolving into the American Ski Classic (ASC). The addition of World Cup events garnered television exposure nationally and internationally, leading eventually to hosting the 1989 World Alpine Championships. (Courtesy of Vail Resorts, Inc.)

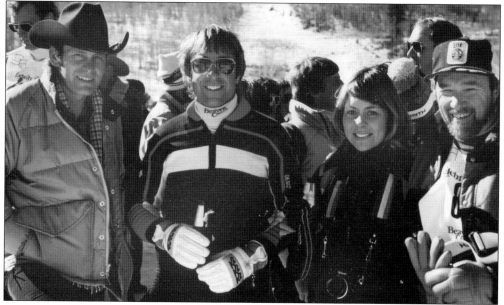

A diverse audience attended the Jerry Ford Celebrity Cup. Among the viewers were, from left to right, Larry Litchliter, director of finance at Beaver Creek Resort; Bob Dorf, director of the ski school and racer in the event; Patty Dorf; and Bob Parker, senior vice president of operations at Vail Associates. (Courtesy of Vail Resorts, Inc.)

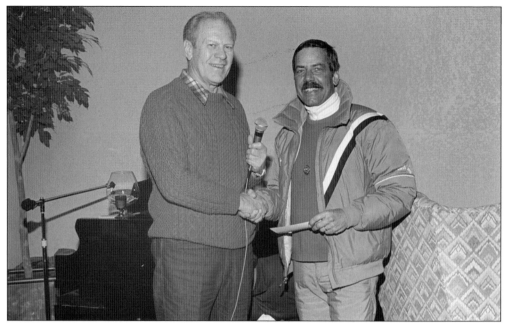

Former president Ford held fundraising events annually. He would award the monies raised to various charities in the Eagle River Valley. Here, Ford presents a check to Don Simonton. Simonton was involved with the Colorado Ski and Snowboard Museum and a youth scholarship, among other boards. Don is sporting his ski school uniform, having just finished his day on the ski slopes. (Courtesy of Vail Resorts, Inc.)

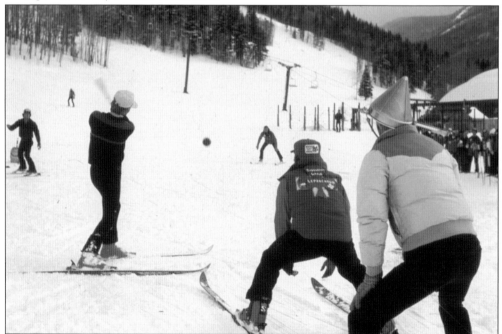

St. Patrick's Day was celebrated at Beaver Creek with a softball game on skis. Ski school challenged the ski patrol to play once the lifts were closed that day. During the day, skiers received shamrock stickers for their skis as they boarded the Centennial lift. (Courtesy of Vail Resorts, Inc.)

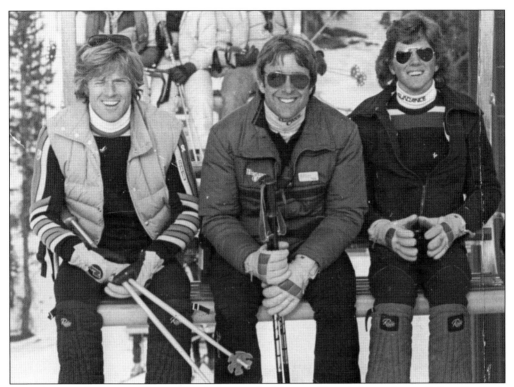

From the very first season, Beaver Creek attracted celebrities. From left to right are Robert Redford; Bob Dorf, director of ski school; and Jamie Redford. The three headed up to Spruce Saddle on the Centennial lift. The Redfords were frequent skiers at Beaver Creek, usually during Presidents Day weekend in February. (Courtesy of Bob Dorf.)

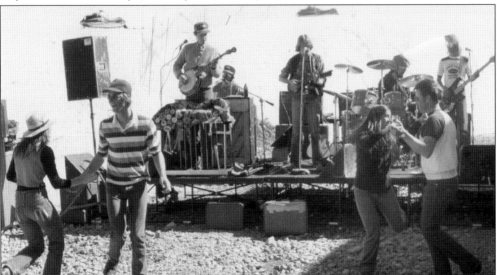

Resort employees are celebrating the end of the first ski season at Beaver Creek. A live band, food, and libations lent a festive atmosphere for the party. In its fledgling year, Beaver Creek closed with just over 111,000 skier days (a day of skiing purchased at the resort) on its 450 skiable acres serviced by seven lifts. (Courtesy Dann Coffey.)

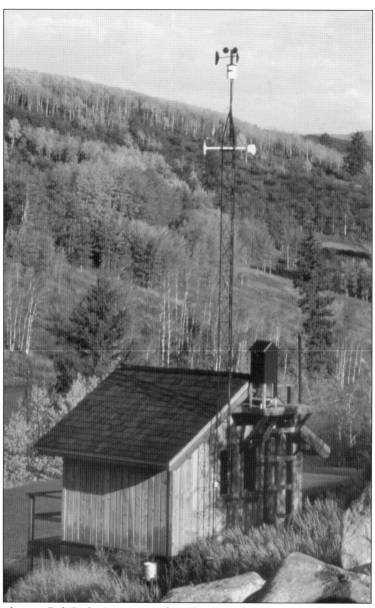

Dave Mott, who was Bob Parker's assistant, describes how the air monitoring system was created. "During the State's environmental review of the Beaver Creek project they were concerned about potential air pollution caused by fireplace emissions. Following an extensive meteorological study it was demonstrated that the mountain valley consistently experienced diurnal airflow up and down the valley as opposed to the air stagnation characteristic of the Denver area. Typically, warming temperatures during the day caused the air to rise and flow up valley, while at night cooling air drained down valley. This daily reversal of airflow had a flushing action that prevented pollution build-up. Nevertheless, Vail Associates agreed to monitor the air quality to satisfy their concern. All wood burning fireplaces were equipped with a red alarm light that was centrally activated, should air quality in the village drop below air quality standards. A red light would signal prohibition of wood burning." Cliff Simonton, environmental coordinator during Beaver Creek's early years, designed the air monitoring station pictured. (Courtesy of Cliff Simonton.)

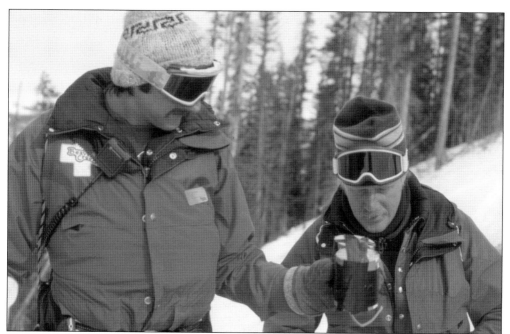

Ski patrollers Rick Schloss and Bruce King are holding four pounds of avalanche charges. They needed to go to Peregrine ski run and throw charges to dislodge any potential avalanche danger. Once they threw the charges, the only thing that came off the run was dirt and rocks. It was definitely low snow if no snow was blown up into the air. (Courtesy of Dann Coffey.)

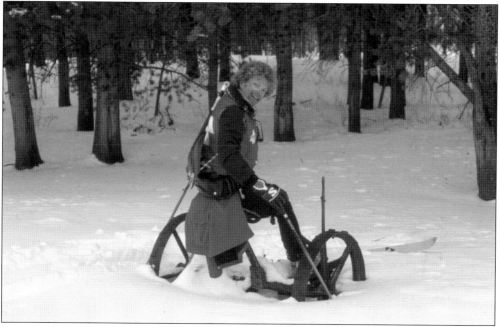

Reminiscent of the early years of the area, ski patrolman Kent Gubler stands over a long-forgotten farming implement. At one time a cash crop farm area, Beaver Creek subsequently provided excellent ranching for sheep and cattle. Large meadows grew hay and feed for the livestock. (Courtesy of Dann Coffey.)

David Edeen (left) stands with Herb Eaton in front of the tennis bubble. David was food and beverage manager, and Herb was part of the lift crew. They were part of the large talent base that made Beaver Creek the resort it is today. (Courtesy of Dann Coffey.)

Patrolman Dann Coffey and Jaimie Gainsboro Stone are celebrating at Beaver Creek's end-of-season party. Dan is sporting raccoon eyes, a ski fashion statement. Raccoon eyes result from eyewear protection and inadequate sunscreen protection of skin. An avid skier and photographer, Dan became a professional photographer after his patrol days. (Courtesy of Dann Coffey.)

Six

TWICE THE GEM

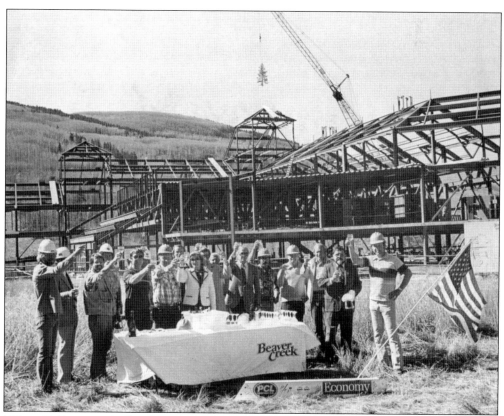

Village Hall is topped off with a toast! A long-standing construction tradition, topping off signals the last highest beam placed on a building. Once in place, the workers sign that beam and place a tree atop the structure by crane. The tree is symbolic for good will toward future inhabitants. Key individuals attending were Dean Kerkling, Roger Lessman, Harry Bass, and Larry Litchliter. (Courtesy of Vail Resorts, Inc.)

Beaver Creek provided an ideal habitat for beavers. Beavers gather small trees and willows in order to form their lodges and dams. During early construction, the developers planted young trees along the creek. The trees were disappearing quickly due to the beaver activity. Jim Schmidt was hired by the developers to live trap the beavers. Subsequently, the beavers were relocated. (Courtesy of Cliff Simonton.)

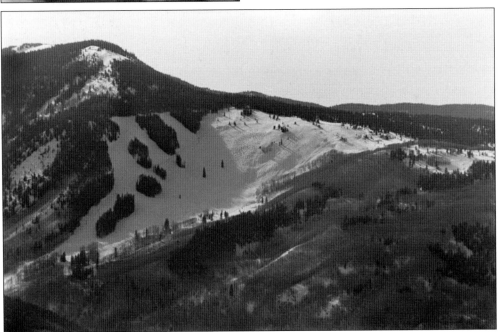

Larkspur Bowl was created to become the first bowl area at Beaver Creek. To the left sits McCoy Peak. Construction was under way in September 1981. Chair No. 12 serviced this area the first few years. The addition of Chair No. 11 enabled skiers to access more runs in the bowl as they were added. (Courtesy of Vail Resorts, Inc.)

Looking up from Red Tail Camp, construction of a new chairlift unfolds in the mid-1980s. Helicopters are carrying lift towers up Larkspur Bowl as they build Chair No. 11. Eventually, Birds of Prey, Grouse Mountain, and Larkspur Express chairlifts would be accessible from Red Tail Camp. (Courtesy of Vail Resorts, Inc.)

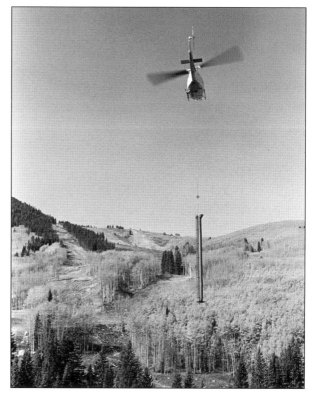

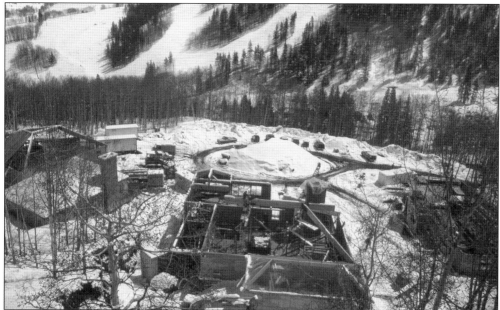

A residential cul-de-sac was developed under Chair No. 12. Four friends bought adjacent lots. The owners included former president Jerry Ford and wife, Betty; Ambassador Firestone; Kaiser Markus; and Dean Keaton. To keep a consistent building theme, they all used the same architect and contractor. The house under construction, center, belonged to Jerry and Betty Ford. (Courtesy of Cliff Simonton.)

721 Binnacle Point Drive
Longboat Key, Florida 34228
813-383-8900

*Jer - This is
very interesting.
P.*

21 June 1994

President Gerald R. Ford, Jr.
Beaver Creek, CO

PICTURES OF THE HOLDEN PLACE
CIRCA 1936; AVON, COLORADO

Dear Sir:

I have pleasure in enclosing some pictures of the upper Beaver Creek area which were taken in 1936 by Mr. Wilbert H. Manning. Mr. Manning and his wife, Bonniebell, lived and worked as tenants on the ranch called the Holden Place until it burned down a few years later. Mr. Manning believed that the location of your present house at Beaver Creek is very close to the place where the house at the Holden Place was located. You should be able to judge from the pictures whether that is indeed the case.

It is interesting to note the type of agriculture, and the reliance on horses pursued a scant 60 years at that relatively high altitude. When I worked for him, Mr. Manning said that it could freeze there almost any night of the year, but that the strong sunlight from the high, clear air made the potatoes almost jump from the ground in the short growing season. To me the pictures evoke a sense of nostalgia for the way of life that seems to have almost passed from our scene, as well as the strong and loving character of the people who lived there.

These pictures were given to me by the second Mrs. Manning with the thought that, in view of the above, they should be forwarded to you. I sincerely hope that you enjoy them.

Very truly yours,

Weldon G. Frost

cc: Mrs. Mary Lou Manning
Rifle, Colorado

In June 1994, a letter was sent to Jerry and Betty Ford regarding the history of their lot at Beaver Creek. A gentleman by the name of Weldon Frost, who worked for a couple called the Mannings, was given photographs taken by Wilbert Manning in 1936. The Mannings lived and worked as tenants on the ranch called Holden Place until it burned down. Frost explained that the Fords' home was very close to the location of the Mannings' house at Holden Place in the 1930s. In the upper right-hand corner is the following note from Ford's Colorado chief of staff Penny Circle: "Sir-this is very interesting. P." The Ford property in Beaver Creek included a building for his Secret Service detail. (Courtesy of Denver Public Library, Western History Collection [WH1605.])

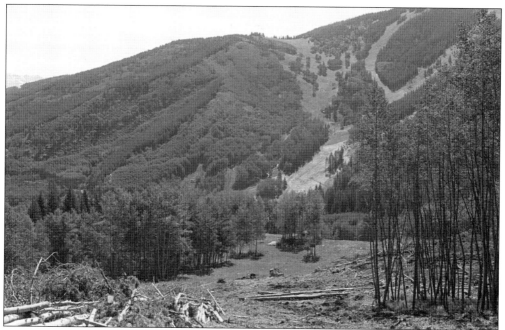

The V-shaped clearing at top right includes Goshawk and Peregrine. To the left is Redtail ski run that was hand cleared by mountain planners Mike Larson and Tom Allender. Larson felt it was important to do this by hand in order to develop a conventional ski run with glade and tree skiing. (Courtesy of Vail Resorts, Inc.)

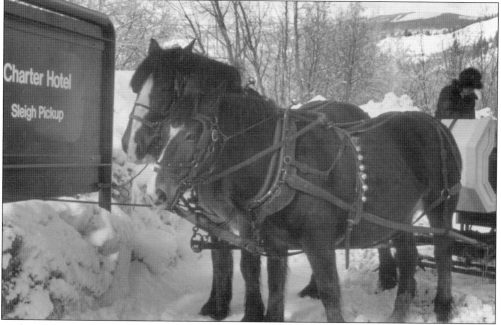

In the early 1980s, the Charter Hotel offered romantic amenities, such as horse-drawn sleigh rides to its guests. Located within walking distance to the village, the Charter was conveniently located across the street from the Robert Trent Jones Jr. golf course. This luxury condominium property was perfectly situated for year-round enjoyment. (Courtesy of Vail Resorts, Inc.)

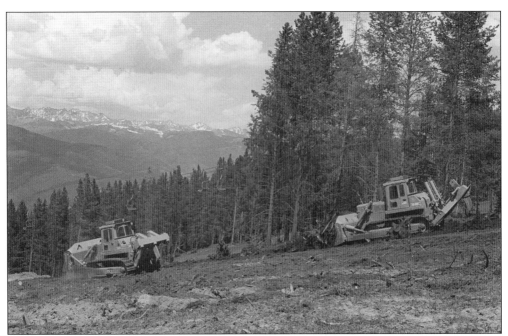

Summer construction begins near the top of Lift No. 9. Looking east, one can see the chairlift that would be running over Centennial ski run. This area in the early days was called Flat Tops; today, it is near Park 101. The machines provide revegetation on the run by clearing rock and tree stumps, thus allowing natural grasses to grow back. (Courtesy of Vail Resorts, Inc.)

Three men who were instrumental in the early days of Beaver Creek Resort development are, from left to right, Earl Eaton, Bill "Sarge" Brown, and Bob Parker. As a result of their work, both at Vail and Beaver Creek, Vail Associates awarded all three gentlemen with lifetime pensions. (Courtesy of Vail Resorts, Inc.)

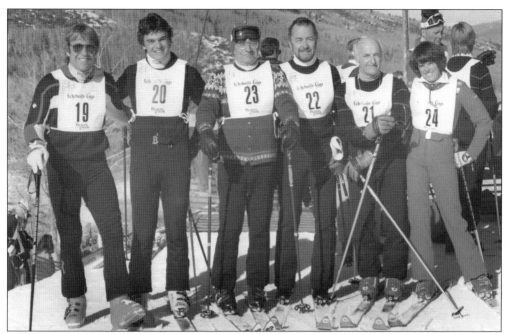

Team captain Kiki Cutter, former US Ski Team Olympian, led the 1981–1982 Jerry Ford Celebrity Cup winning team. Teams were comprised of six members for this race with one former Olympic skier as team captain. Pictured are, from left to right, Bob Dorf, three unidentified people, Max Dercum, and Kiki Cutter. (Courtesy of Bob Dorf.)

In March 1985, a single-engine Piper PA-28-181 airplane was reported missing. The plane, carrying two locals back from a business trip, was due to land at Eagle County Airport. Unfortunately, the plane crashed, and it took days to locate. A Vail Associates employee discovered the plane just off Cinch and Beartrap runs near the bottom of Beaver Creek Mountain. (Courtesy of Vail Resorts, Inc.)

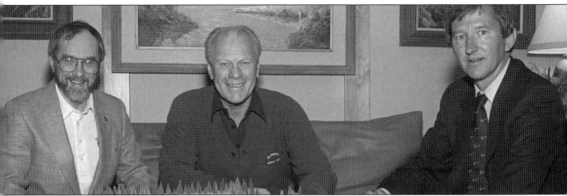

Each of these amazing gentlemen left their mark on Beaver Creek Resort. From left to right are Bob Parker, former president Jerry Ford, and Harry Frampton. Parker, senior vice president of operations for Vail Associates, was credited with navigating Beaver Creek through years of governmental and environmental challenges. A longtime visitor to Vail and subsequently making his home in Beaver Creek, former president Ford and Betty Ford garnered national attention for Beaver Creek. The Fords participated in the community and enjoyed all the amenities offered by the resort. When Harry Frampton became president of Vail Associates, five major projects were stopped, Beaver Creek was undercapitalized, and the national economy was experiencing a major recession. Within the first year and a half of Frampton's leadership, all five projects, comprised of the Charter Beaver Creek, Poste Montane Lodge, Creekside at Beaver Creek, Village Hall, and the Centennial, were headed toward completion. Larkspur Bowl had opened, which helped attract more skiers, and real estate was selling, bringing in revenue that was needed. (Courtesy of Vail Resorts, Inc.)

Golfing was one of the amenities at Beaver Creek. Here is a field review of the proposed course; from left to right are unidentified, Dave Mott, and Robert Trent Jones Jr., course architect. It would take up to two years to build the course, and it would take another "grow-in" year before play could begin. (Courtesy of Vail Resorts, Inc.)

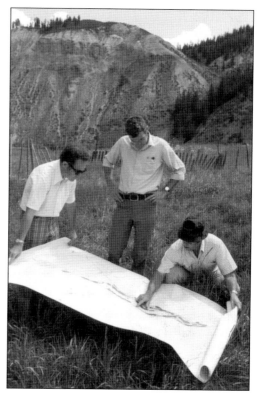

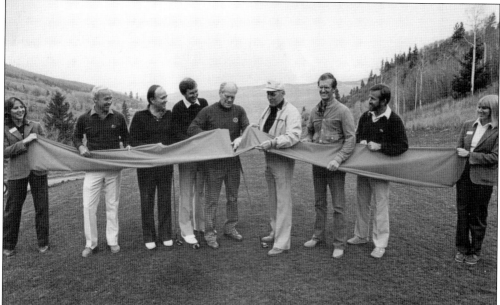

Doing the honors of cutting the ribbon for the opening of Beaver Creek Golf Course is former president Jerry Ford. Also in attendance were Harry Bass, chairman of Vail Associates; Jack Marshall, president of Vail Associates; and Brain Rapp, president of Beaver Creek Resort Company. Beaver Creek Resort was on its way to be twice the gem originally planned. (Courtesy of Vail Resorts, Inc.)

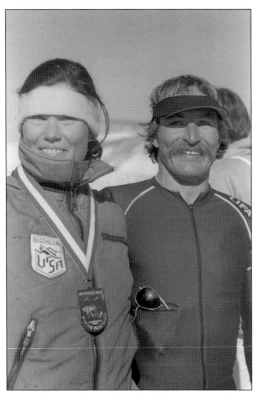

Originally sponsored by Beaver Creek Resort Company and the Town of Avon, the Mountain Man Winter Triathlon showcased three winter sports, cross-country skiing, snowshoeing, and ice-skating. During the early 1980s, Hawaii's Ironman Triathlon was getting national recognition, sparking an idea locally of developing a winter triathlon to spotlight all that the fledgling resort had to offer. Participants, from left to right, Jan Reynolds and Gary Barnett had to cross-country ski 15 miles, then snowshoe 9.1 miles, and lastly, ice-skate 12.6 miles on Nottingham Lake. Reynolds, a former US Olympic Biathlon Team member, is pictured crossing the finish line to win the women's division. She won the event four years in a row. Barnett later continued his involvement with the race as a race organizer. (Courtesy of Vail Resorts, Inc.)

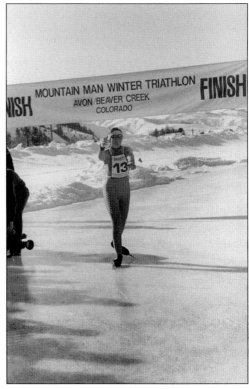

Olympic skier Cindy Nelson addresses a group regarding Vail Associates bid for the 1989 World Alpine Ski Championships. Ultimately, Vail Associates won the bid at the FIS (International Ski Federation) congress, which was held in Rio de Janerio. At the time, Nelson was director of skiing at Vail Associates. (Courtesy of Vail Resorts, Inc.)

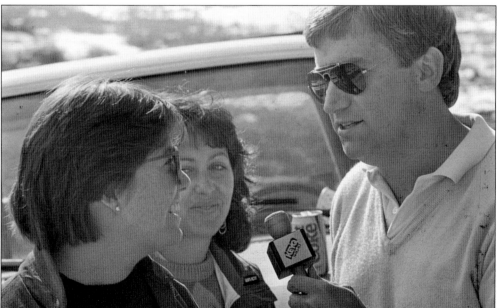

The opening of Rose Bowl created a media event. From left to right are Pat Peeples, public relations director for Vail Associates; unidentified; and Rich Teeters, a local reporter. Vail Associates owner George Gillett named the area after his wife, Rose. The triple chair that serviced the area was replaced with a high-speed detachable quad in 2011. This new chair increased the capacity from 1,600 to 2,400 people per hour. (Courtesy of Vail Resorts, Inc.)

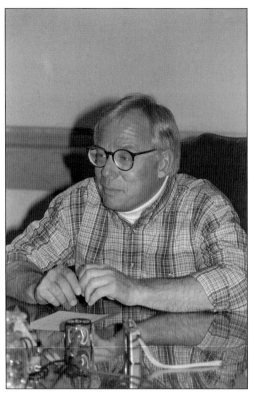

George Gillett's father taught him that it is okay to own a business that is fun, and George bought Vail Associates with that in mind. With the change in ownership came a new president by the name of Mike Shannon. Shannon had a reputation as an acquisitions whiz at the age of 27. The two men went back to basics when it came to Beaver Creek, which meant offering the best skiing, golfing, and outdoor experiences possible for their guests. Gillett and Shannon felt it was best to include outside investment through restaurateurs, hoteliers, retailers, and developers. Vail Associates negotiated the building of Beaver Creek's first hotel with East West Partners. The Hyatt at Beaver Creek opened in time to host the 1989 World Championships. (Courtesy of Vail Resorts, Inc.)

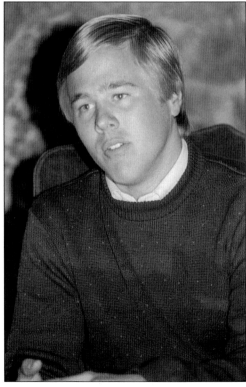

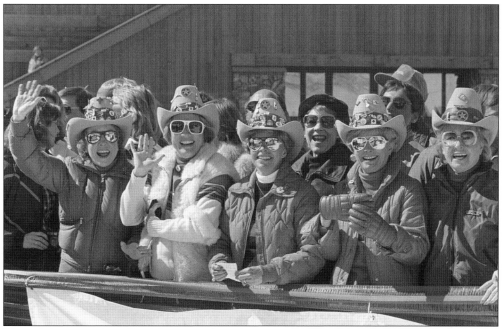

These ladies were the talk of the town when they visited. The Skiing Grandmothers from Texas became part of the fabric of the Jerry Ford Celebrity Cup. They attended the event annually and eventually received credentials to the VIP tent. One year, they were invited to ski on one of the celebrity teams. (Courtesy of Vail Resorts, Inc.)

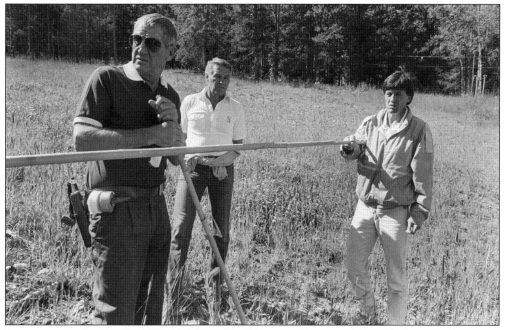

In preparation for the 1989 World Alpine Ski Championships men's downhill event, the course designer visited the site. From left to right are Bill "Sarge" Brown, Pepi Gramshammer, and Bernhard Russi. Skiing legend and FIS course designer Bernhard Russi is measuring the run on Beaver Creek that would become known as Rattlesnake Alley. (Courtesy of Vail Resorts, Inc.)

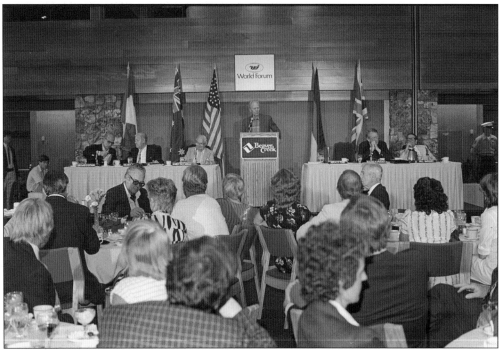

Former president Ford conceived the World Forum to provide business, government, and academic leaders an opportunity to exchange ideas. Hosted annually in Beaver Creek, the event was sponsored by the American Enterprise Institute (AEI), which was a conservative think tank in Washington, DC. Dignitaries from around the world were invited to participate in the World Forum. A panel discussion below includes, from left to right, William J. Broody Jr., Jeane Kirkpatrick, and Henry Kissinger. Broody ran the White House Office of Public Liaison under President Ford and also served as president of the AEI. Kirkpatrick was the first United States women to become US ambassador to the United Nations. Kissinger served as secretary of state under Presidents Nixon and Ford. (Courtesy of Vail Resorts, Inc.)

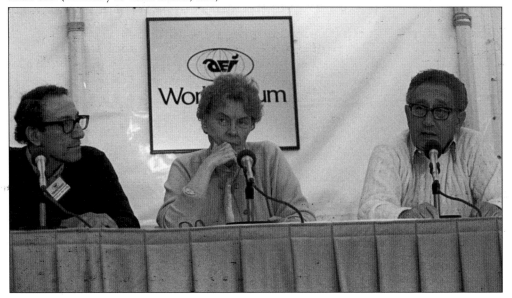

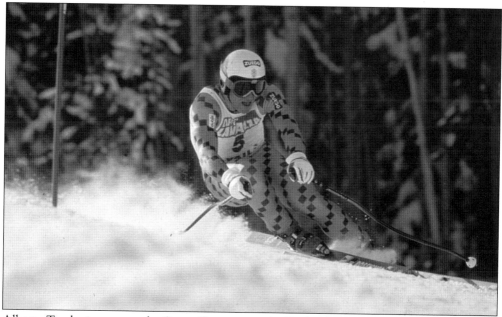

Alberto Tomba is seen on the Super G course on the Birds of Prey. Enthusiastic fans chanted, "La Bomba," as he was affectionately called. Tomba reached superstar status in Italy after his two Olympic gold medals in 1988 at Calgary. The 1989 World Alpine Ski Championships men's events were held at Beaver Creek, and the women's events were held in Vail. (Courtesy of Vail Valley Foundation.)

Bob Knous, president of the Vail Valley Foundation, concluded the event with remarks at the closing ceremonies celebration. "A tremendous sense of accomplishment mixed with an unexplainable longing for the event to continue forever" was the atmosphere that evening, as described by the Vail Valley Foundation. Knous also presided over the World Alpine Ski Championships as president of the organizing committee. (Courtesy of Vail Valley Foundation.)

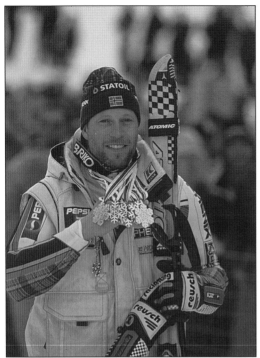

The outstanding 1989 World Alpine Ski Championships (WASC) led to a successful bid of the 1999 WASC. This was the first time a venue hosted the event twice in a 10-year span. In 1999, Norway's Lasse Kjus became the first racer to ever win five medals in five races at a World Alpine Ski Championships. Two were gold, which included the historic gold-medal Super G tie with Hermann Maier of Austria, and three were silver. (Courtesy of Bo Bridges.)

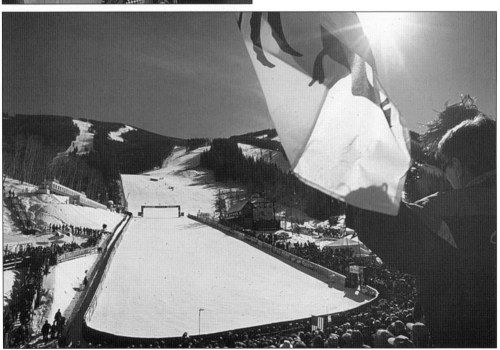

According to the Vail Valley Foundation website, "The 1999 Championships would showcase the largest crowd in US ski racing history for the Men's Downhill, with an estimated 20,000 people on hand to watch Austria's Hermann Maier tame Beaver Creek's Birds of Prey course." Spectators crowd the stands at the Beaver Creek finish area. A bluebird day enhanced the thrill of the races. (Courtesy of Rex Keep.)

Seven

A Broken Arrowhead

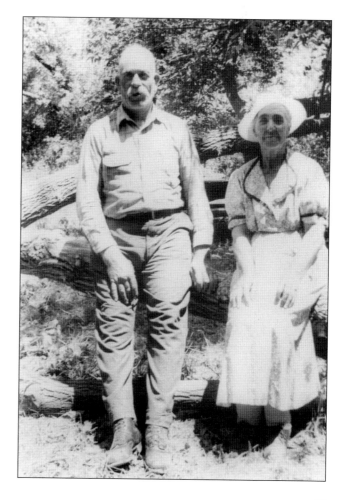

Mike and Irena Dodo visited McCoy Ranch in 1949. The property was just west of Beaver Creek with a small creek, known as McCoy Creek, on its western border. Their son David "Pete" bought the property from Oscar Nelson in 1946. Pete ran a Hereford cattle ranch on the property until he sold it. (Courtesy of Ron Dodd and Lynn Dodo McCray.)

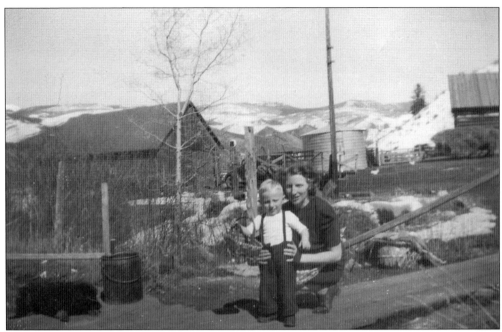

Pete Dodo married Rachel Wagner in December 1935. They had three children, Howard, Ron, and Lynn. Rachel and toddler Ron are pictured near the house with a ranch building in the background. Ron grew up to be a veterinarian and moved to California. Being a veterinarian doctor, he felt Dr. Dodo would not earn confidence with patients, and he subsequently changed his name to Dodd. (Courtesy of Ron Dodd and Lynn Dodo McCray.)

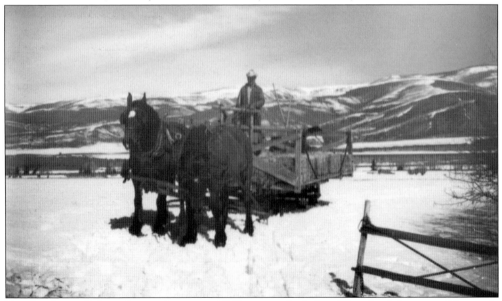

Two Percheron/Belgian horses, Prince and Billy, are at the helm of Pete Dodo's wagon. The cattle were fed once a day 20–30 pounds of hay per cow. Dodo was a lifelong rancher and a member of the Eagle County Cattleman's Association, serving as president in 1950–1951. For 15 years, he served on the Agricultural Stabilization and Conservation Service Committee for Eagle and Garfield Counties. (Courtesy of Ron Dodd and Lynn Dodo McCray.)

Lynn Dodo, left, is heading on Pete's favorite horse, Redwing, and Pete Dodo, on Amos, is healing a yearling heifer. The heifer was being caught for a visit to a veterinarian for a foot infection. Pete loved Hereford cattle, good horses, and his dogs according to his 2005 memoriam. (Courtesy of Ron Dodd and Lynn Dodo McCray.)

It is no surprise Pete Dodo loved his Herefords, as they possess a docile temperament and are known to thrive in less-than-perfect conditions. Efficient converters of grass and grain, they do more with less. A hardy breed, they are also very fertile and exhibit fine maternal instincts. Here, Dodo finishes feeding his Hereford cattle at the Avon Ranch. (Courtesy of Ron Dodd and Lynn Dodo McCray.)

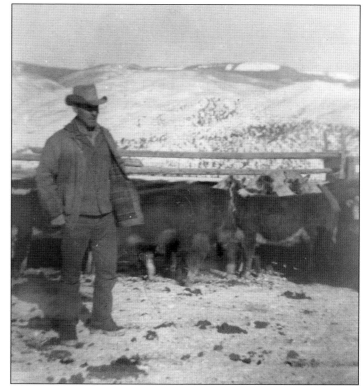

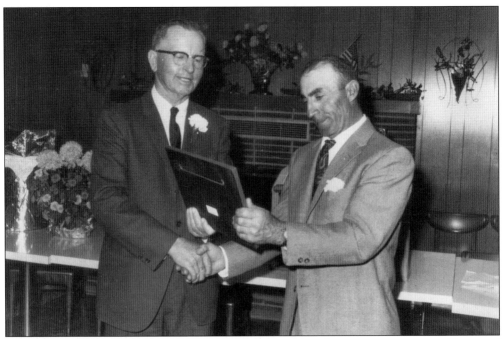

An unidentified state official, left, presents Pete Dodo with a plaque commemorating 15 years of service with the Agricultural Stabilization and Conservation Service (ASCS). The ASCS was an agency of the US Department of Agriculture. Born into ranching, Pete was very cognizant of being involved in environmental protection and resource conservation. (Courtesy of Ron Dodd and Lynn Dodo McCray.)

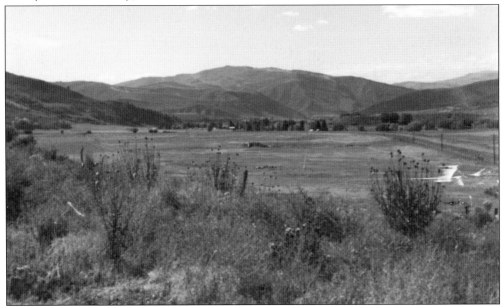

This view is looking west from the Dodo Ranch. Pete bought the property in 1946 and worked hard to level it. He would hire help to take the hills and bumps out of the pasture. After selling the ranch to a developer, he was amused at how, after all his efforts of leveling the land, hills were added to the property. (Courtesy of Ron Dodd and Lynn Dodo McCray.)

Wood paneling enhances the warmth of Ralph Dodo's home. Seated are, from left to right, Ralph, Jim, and Pete Dodo, just two of Pete's five brothers. Pete came from a large family, which included four sisters. In Western fashion, Pete sports a bolo tie. He lived to the age of 96. (Courtesy of Ron Dodd and Lynn Dodo McCray.)

Jim Krentler from Colorado Springs bought Pete Dodo's 1,200-acre ranch in 1972. The ranch was 12 miles west of Vail with property adjacent to Beaver Creek Resort. Krentler invested in the land speculating a good return with Colorado hosting the 1976 Winter Olympics. When the state vetoed the Olympics, Krentler decided to sell the property. (Courtesy of Marty and Jack Mankamyer.)

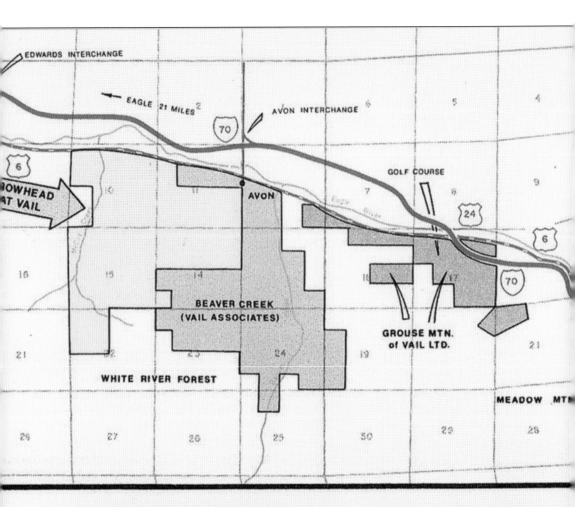

"ARROWHEAD AT VAIL"

Putting the property up for sale entailed much research and marketing. The property was named Arrowhead at Vail after a quartz arrowhead was discovered on the property. Marty and Jack Mankamyer worked with Krentler on positioning the property to sell. The Mankamyers felt the property had more value with an approved plan by Eagle County. They hired Daniel, Mann, Johnson, and Mendenhall, planners from San Francisco, California. The master plan proposal,

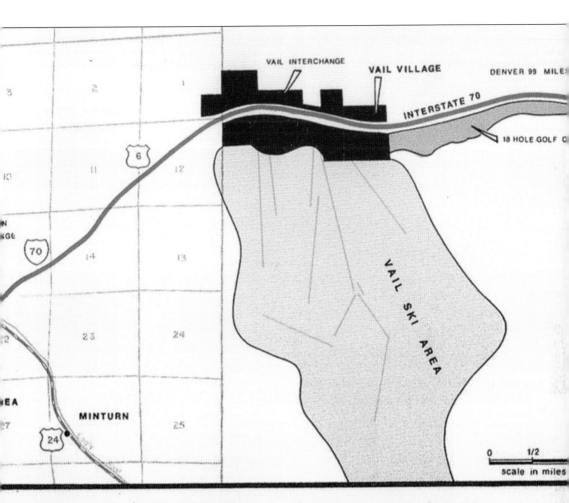

INTERSTATE 70

18 HOLE GOLF C

VAIL SKI AREA

6

70

MINTURN

24

0 1/2
scale in miles

GLE COUNTY, COLORADO

shown here, by architect-planner Jared B. Morse, included residential development and a golf course. It took seven years to sell the property. Wedge Corporation from Houston, Texas, bought the property in 1979 with the master plan in place. This was the largest raw land deal ever in Colorado at the time; it sold for $9 million. (Courtesy of Marty and Jack Mankamyer.)

When Marty Mankamyer was hiking and exploring the property one day, she came across a white quartz arrowhead. Wondering if it was authentic, she took it to the Natural History Museum, which confirmed it was a true artifact. The museum promptly tried to keep it; however, Marty informed them that it was found on private property, which enabled her to keep it. (Courtesy of Marty and Jack Mankamyer.)

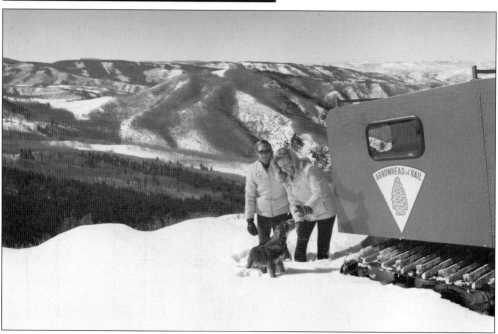

A snowcat was used to bring prospective buyers around the Arrowhead at Vail property. Looking north across Highway 6 and the Eagle River renders this view from the top of the property. In front of the snowcat stands an unidentified man with Marty Mankamyer and a dog. (Courtesy of Marty and Jack Mankamyer.)

Arrowhead at Vail became an exclusive residential development with a Jack Nicklaus–designed golf course and a ski area. A snapshot from the top of the property looking north in the early 1970s features lush meadows and foliage. The area was a prime wildlife corridor for elk and deer. (Courtesy of Marty and Jack Mankamyer.)

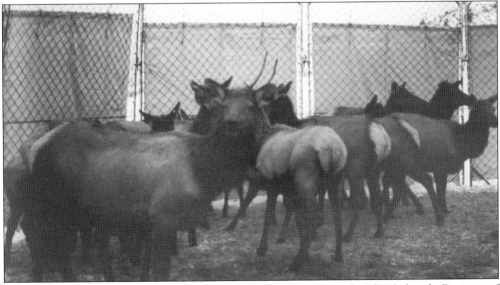

Development in the wildlife corridors put pressure on the elk herds. The Colorado Division of Wildlife (DOW) in the 1980s began tracking migration of the elk in the Arrowhead area. Corral traps consisting of steel frames overlaid with mesh and hung with vinyl curtains were constructed. The elk were enticed into these 50-foot-radius enclosures with salt blocks and hay. (Courtesy of Bill Andre Colorado Division of Wildlife Officer.)

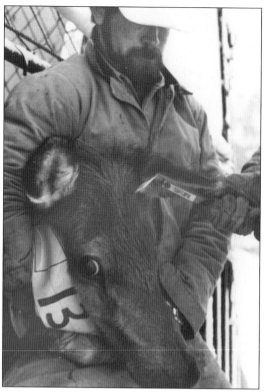

Bill Andre of the Colorado Division of Wildlife holds an elk for ear tagging. In addition to the cloth collars placed on the necks of elk, the DOW would also tag their ears with a number in case the collar was lost. Eventually, they would only tag ears with two different symbols that were easily seen with a spotting scope at a distance. (Courtesy of Bill Andre, Colorado Division of Wildlife officer.)

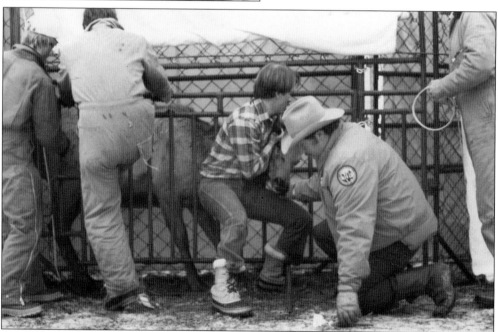

Putting collars on the elk in order to track them was a physical job. The cloth collars had radio transmitters built in that allowed tracking. Here, an unidentified man and Bill Heicher, wearing his uniform, "mug" an elk, which is when a person grabs an animal and brings it down to put a collar on its neck. (Courtesy of Bill Andre, Colorado Division of Wildlife officer.)

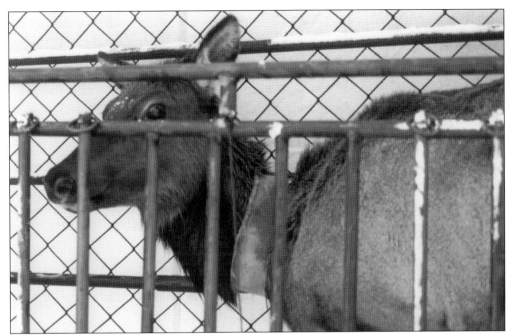

Here, a collared elk looks out of an Arrowhead corral. Since the collars were cloth, they would disintegrate and fall off after a few years. DOW was able to determine the areas they would migrate to in the summer using the collars. The elk would go south of Interstate 70 toward Grouse Mountain, near Minturn, and as far east as Vail Pass and Wilder Gulch. (Courtesy of Bill Andre, Colorado Division of Wildlife officer.)

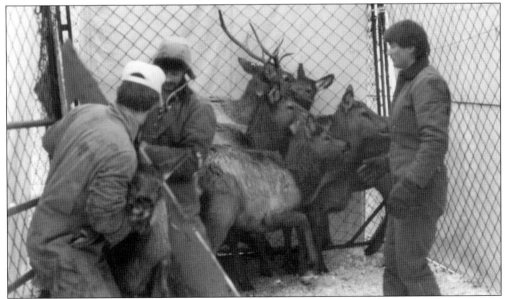

Small bulls and cows are in a corral trap with curtains. From left to right are unidentified, Bill de Vergie, and Jim Yoder. De Vergie was a student at Colorado State University, earning his master's in wildlife biology, and helped with the migration study. Jim Yoder was hired as a temporary employee by the Forest Service and also worked on the elk migration. (Courtesy of Bill Andre, Colorado Division of Wildlife officer.)

Ron Brown uses a transit to shoot grades for the foundation of one on the first homes on Holden Road in Beaver Creek during the summer of 1983. Brown was the local builder hired for the project. The backdrop is the Beaver Creek Golf Course with Avon in the background. Avon had very few buildings with limited commercial development in 1983. (Courtesy of Ron Brown.)

Fresh skier tracks are pictured in January 1984 near the 120 Holden Road home. The home featured an indoor swimming pool. After the pool had been filled with water, the contractor found footprints in the bottom of the pool. Alarmed at the sight of prints, he contacted the pool installer saying it was defective but discovered that a workman had used the pool the night before. (Courtesy of Ron Brown.)

A contractor's sign displays the firms involved with the custom home at 120 Holden Road. Aren Design custom made all the woodwork inside the home. This was a very unique residence feature, as was the elaborate indoor swimming pool with hot tub. Tall round columns around the pool were custom stained to match the rest of the home's wood trim. (Courtesy of Ron Brown.)

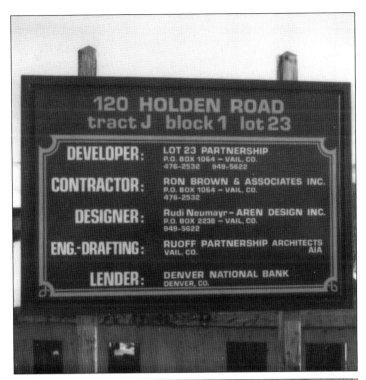

Poste Montane is completed after years of construction setbacks. The property was designed as a small European-style lodge in the heart of Beaver Creek. Featuring 24 suites, it would be one of the first lodging properties open in the resort. In addition to lodging accommodations, visitors could inquire about interval ownership at the lodge. (Courtesy of Vail Resorts, Inc.)

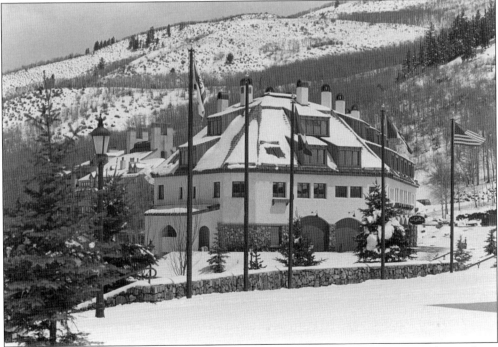

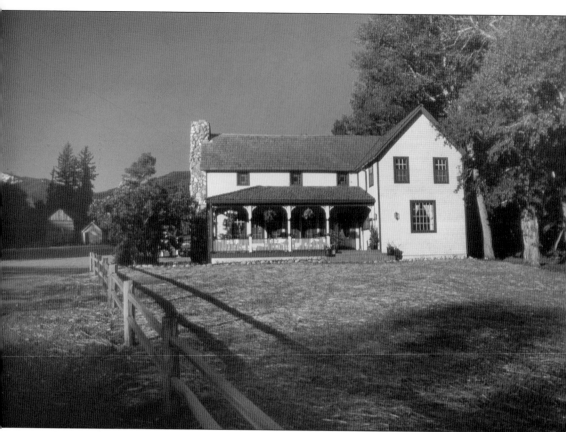

This farmhouse boasts a long and colorful history. In late 1889, John Howard, an early rancher, constructed the west wing of the building. Later, cattle rancher Gulling Offerson purchased the property and added on to the front of the building, including the porch. Willis Nottingham then acquired the property, and then Vail Associates purchased it. During the building of Beaver Creek Resort, a local couple lived in the home. The husband was working on the development of the resort. Once the resort opened, it transformed into Mirabelle restaurant in June 1982. Belgium master chef Daniel Joly took over the restaurant in the late 1980s, accumulating accolades from national publications and his guests since then. (Courtesy of Cliff Simonton.)

Eight

THE LAND OF DREAMERS

Here is the entrance to Beaver Creek as it appeared in 1983 with Mirabelle restaurant in the background. Masonry like this would be featured throughout the resort in commercial building and residences. The Gallegos Corporation, a local family-owned and -operated business was responsible for much of the beautiful stonework in Beaver Creek. (Courtesy of Cliff Simonton.)

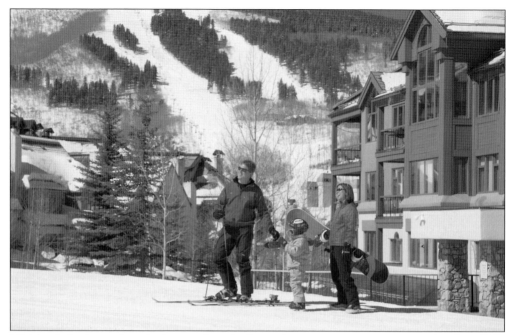

Highlands Lodge, a three-bedroom, three-bath condominium project, was completed in 1989. This family-friendly property adjacent to the slopes echoed the Southern European mountain architectural designs at Beaver Creek Resort. A young family prepares to enjoy a sunny day skiing on the mountain. (Courtesy of East West Resorts.)

Built by East West Partners, Villa Montane features large townhomes. The residences' ski locker room is steps from the Elkhorn lift and slopes. A three-level parking garage was built as a collaboration between East West Partners and Vail Resorts. Several parking spots were sold to raise money to build the townhomes, which were completed in 1998. (Courtesy of East West Resorts.)

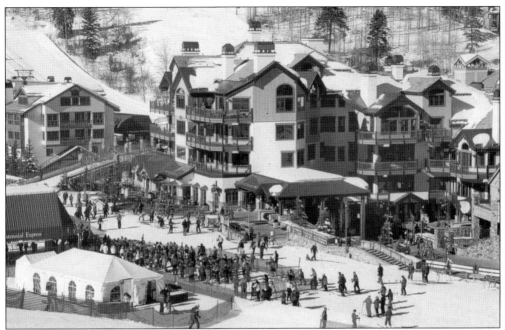

As the resort matured, amenities for the skiers increased. Escalators were installed as part of the design of One Beaver Creek, allowing easy access to the Centennial lift. No longer would skiers in ski boots have to walk up a flight of stairs. The center of activity and residences closest to the Centennial lift, One Beaver Creek was completed in 1997. (Courtesy of East West Resorts.)

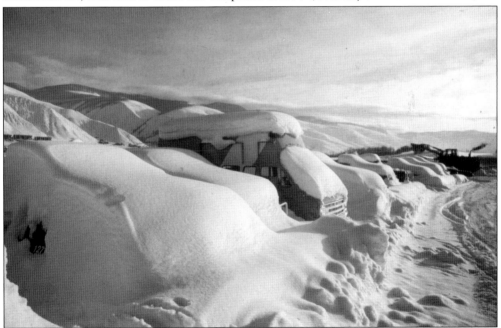

Vehicles parked at the bottom of Beaver Creek illustrate how much snow had accumulated in February 1984. This snow, along with the warm spring temperatures, would contribute to several mudslides from West Vail to Beaver Creek, which left a path of destruction. (Courtesy of Cliff Simonton.)

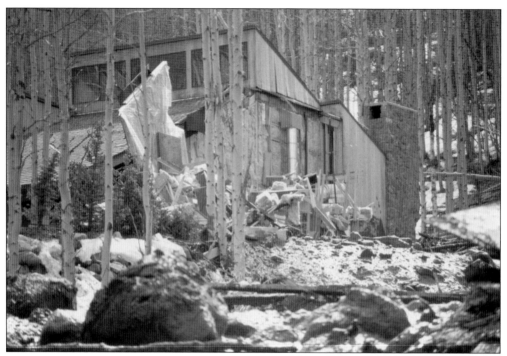

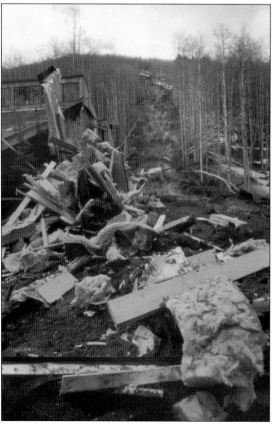

Normally in the central Rockies, the snow at lower elevations disappears slowly through early spring, melting and evaporating over many weeks of cool days and relatively cold nights. By the time spring runoff really kicks in, most of the snowmelt is occurring at or above 10,000 feet. However, 1984 was a unique early-season melting event after a heavy-snow year, recalled Cliff Simonton. The spring of 1984 had a week of very warm weather while snow was still deep on the ground around the 8,000-foot level. The snow melted in a hurry, saturated the soil profile, and a mudslide occurred, hitting the De Lalama home in Beaver Creek. (Courtesy of Cliff Simonton.)

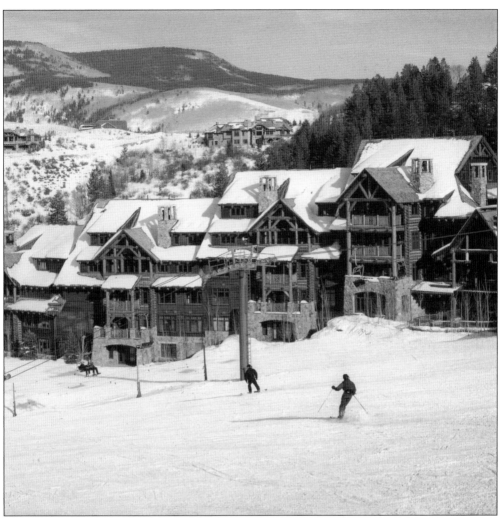

Bachelor Gulch was described as the exception when a three-hour homesite sale generated $42 million. In August 1995, this was Eagle County's largest land sale; in addition, it was also one of the largest one-day residential sales in the United States. Bachelor Gulch achieved the long-term vision of pioneer Pete Siebert, which was to build a European-style village-to-village ski experience. In contrast to the Tyrolean Vail Village architecture or Southern European mountain style in Beaver Creek, grand lodges of America's national parks would be emulated in Bachelor Gulch designs. Another distinctive feature of Bachelor Gulch, rarely seen in other North American ski areas, was 85 percent of residences offered ski-in and ski-out access. As stated on the Bachelor Gulch website, "At Bachelor Gulch, virtually all of the land is private property and most of that is on the mountain." Snow Cloud residences are located steps from the Bachelor Gulch Express lift. (Courtesy of East West Resorts.)

Four guests stand in front of Trapper's Cabin; they are, from left to right, Linda Overcash, Linda Mueller, Cathy Schaeffer, and Laura Chiappetta Thompson. This luxurious lodge sits tucked away between Beaver Creek and Arrowhead villages. Included in the amenities were libations and a cabin host to prepare cocktails, dinner, and breakfast. It was a beautiful ski-in and ski-out location to gather with friends for a birthday celebration. (Author's collection.)

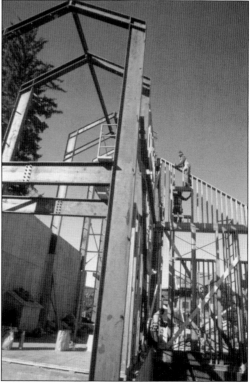

Arched steel framing appears as part of a notable 1984 home in Beaver Creek. The house would boast over 20,000 square feet and would include a waterfall with the pool and an extra-large gas line. A Mexican family who had a reputation of driving exotic cars around the valley and throwing extravagant parties owned it. (Courtesy of Cliff Simonton.)

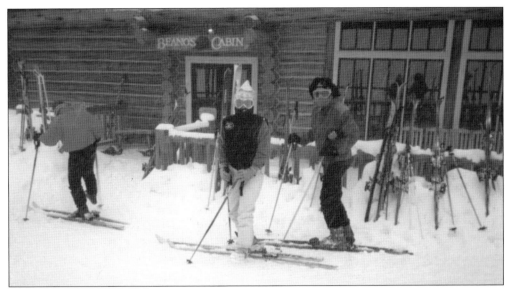

Beano's Cabin restaurant is named after an early settler by the name of Bienkowski. Known to his neighbors as Beano, he lived in Bachelor Gulch. After a gourmet lunch, the ladies, from left to right, Linda Mueller, Linda Overcash, and Laura Chiappetta Thompson went out for more powder turns on Beaver Creek Mountain. (Author's collection.)

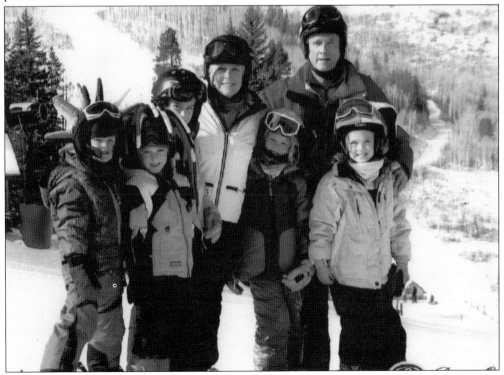

Beaver Creek was designed to be a family-friendly resort. Depending on the season, guests can choose from a variety of outdoor activities. From left to right, Witt Young, Joe Yoder, Mary Yoder, Nancy Young, Ella Young, Hap Young, and Nancy Yoder enjoy a ski day together. (Courtesy of Nancy and Hap Young.)

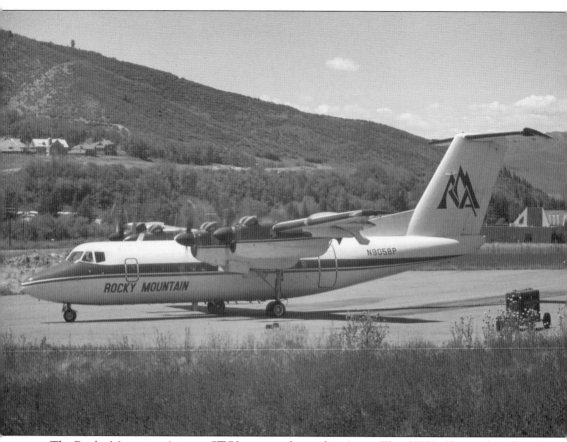

The Rocky Mountain Airways STOLport was located in Avon. This STOL (short take-offs and landings) airfield was on Bill Nottingham's property. It sat just west of the present Walmart and Home Depot shopping center. A special-use permit from Eagle County had restricted use to only Rocky Mountain Airways (otherwise known as Rocky Mountain Scareways) and medevac aircraft. Because mountains surrounded the airstrip and the short runway length, a special plane was needed to land here. A passenger de Havilland Canada DCH-7 Dash 7 was designed specifically for this type of airfield. Rocky Mountain Airways flew direct flights from Denver International Airport, bringing visitors to the area year-round. Pilots needed a specific type rating to land here since this airfield was reportedly the steepest approach in the world, according to Jon Silver, a former captain with Rocky Mountain Airways. A Dash 7 sits on the runway with the entrance to Beaver Creek in the background. (Courtesy of Eduard Marmet.)

Nine

PRESIDENT FORD
AND FAMILY

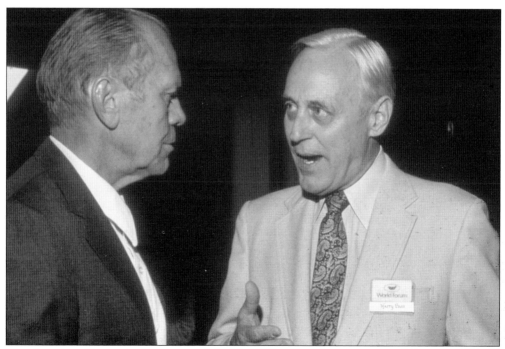

The American Enterprise Institute and the Vail Valley Foundation sponsored the annual World Forum in Beaver Creek, founded by former US president Ford. Its purpose was to gather government and business leaders to discuss international strategic and economic issues. Harry Bass, president of Vail Associates (now Vail Resorts), visits with President Ford at the World Forum. (Courtesy of Vail Resorts, Inc.)

Pres. Gerald and Betty Ford built their home on a cul-de-sac directly under the Strawberry Park chairlift. The house had views of Beaver Creek Resort as well as being a ski-in and ski-out property. A detached building housed the lap pool, hot tub, and exercise bike. Swimming daily was part of President Ford's workout routine. Their home was designed with seven bedrooms and spanned 11,000 square feet. The living room featured views to the ski mountain and offered several seating areas. After President Ford was out of office, he continued to work six days a week. The study had his desk surrounded by solarium windows, with a view to the gardens surrounding the house. (Courtesy of Vail Resorts, Inc.)

For years, the Beaver Creek Christmas Tree Lighting ceremony was hosted by President and Betty Ford. The annual event marked the beginning of the holiday season. The Ford family was involved in many events over the years. Here, Betty and Jerry are taking a sleigh ride after the tree lighting ceremony. Courtesy of Vail Resorts, Inc.)

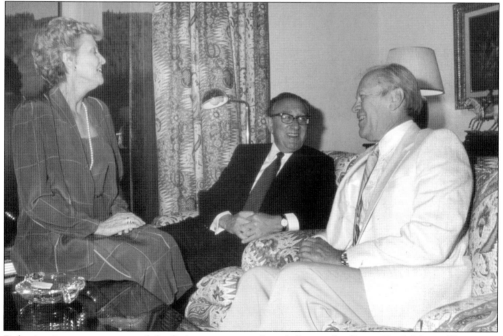

Relaxing in a cozy corner of the living room are, from left to right, Betty Ford, Henry Kissinger, and Jerry Ford. They were good friends for many years; Kissinger was a professor at Harvard when he met Ford. At the time, Ford was a congressman for Michigan. When Kissinger was in town, he reportedly stayed next door at Leonard Firestone's house. (Courtesy of Vail Resorts, Inc.)

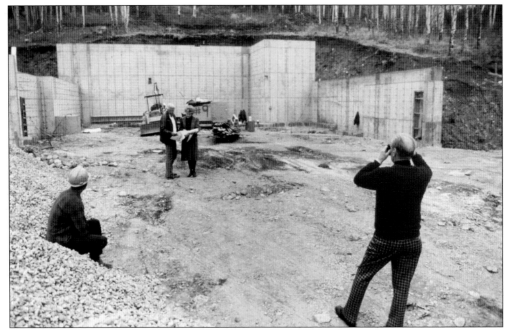

Betty Ford largely led building the Beaver Creek house. She was the construction savvy one of the couple, according to a close friend. Jerry Ford is acting as photographer, documenting the moment of Betty reviewing blueprints with the contractor. (Courtesy of Vail Resorts, Inc.)

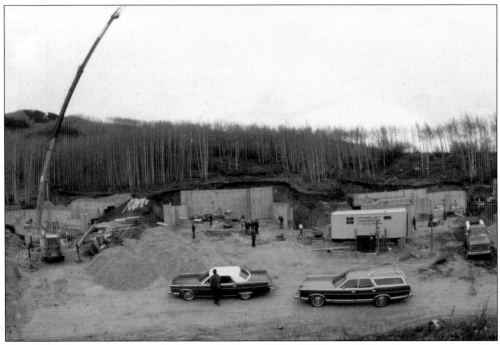

One of the first custom-home builders in Vail was J. Mitchell Hoyt. All four homeowners on the cul-de-sac on which the Fords' home would be located hired the same architect. By hiring the same architect, they would ensure a consistent look and feel of the four homes. (Courtesy of Vail Resorts, Inc.)

President Ford is surrounded by a group of men, probably Secret Service, as he leaves Spruce Saddle restaurant. He is near the top of Beaver Creek Mountain and headed out to ski. Although he was frequently portrayed by the media as being clumsy, he was quite the athlete his entire life. (Courtesy of Vail Resorts, Inc.)

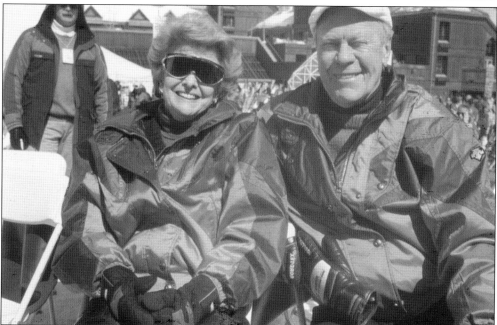

Former president Ford and former first lady Betty sit at the American Ski Classic (ASC) on a sunny day. He created the event out of his passion for skiing. Since Beaver Creek was very new and relatively unknown, the American Ski Classic exposed celebrities, as well as ski legends to what the resort offered. (Courtesy of Vail Resorts, Inc.)

The Fords' home was designed to entertain a large number of guests. It was especially beautiful in the summertime, which encouraged the use of the outside decks for receiving their many friends. Note the gentleman at left serving hors d'oeuvres to the party attendees. The house included a caterer kitchen in addition to the main kitchen. (Courtesy of Vail Resorts, Inc.)

President Ford is pictured playing the Beaver Creek Golf Course, shooting for the 15th green. He enjoyed golf very much and would play often, as the golf course was a short distance from his home. The barn behind the green belonged to the pioneer Holden family. (Courtesy of Vail Resorts, Inc.)

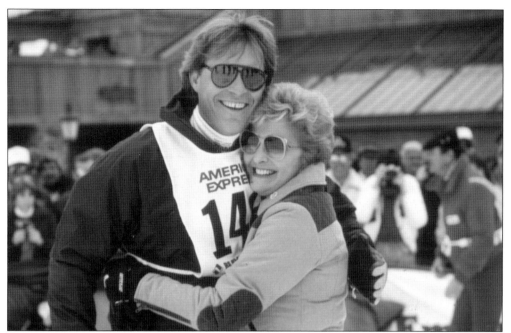

Jack Ford gets a huge hug from his mom, former first lady Betty Ford, at an American Ski Classic event in Beaver Creek. Born John "Jack" Gardner Ford, he was the second child and had three siblings, Susan, Steven, and Michael. He was part of the founding group that started *Outside* magazine. (Courtesy of Vail Resorts, Inc.)

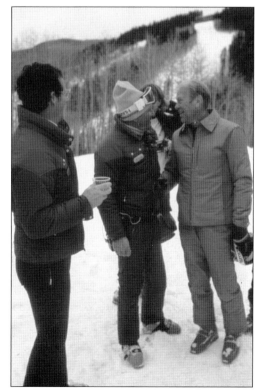

Bill "Sarge" Brown, left, was mountain manager of Vail and Beaver Creek when Beaver Creek first opened. He is wearing the original brown and rust-colored uniform worn at Beaver Creek in the early days. Being former military, Sarge gave the former commander in chief Jerry Ford certain perks when he was skiing Beaver Creek. (Courtesy of Vail Resorts, Inc.)

The Strawberry Park Express lift moves its way up the mountain over Betty and Jerry Ford's home. The house sits in an idyllic snowy setting surrounded by mountains. Eventually, a run called President Ford's would be added to the area just south of Stacker. (Courtesy of Vail Resorts, Inc.)

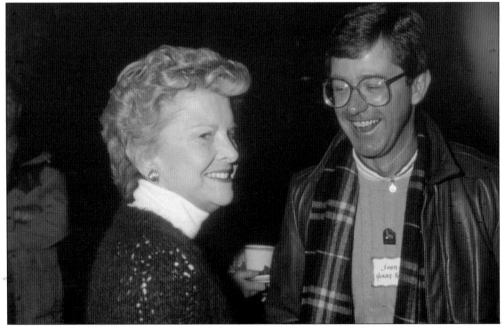

The Fords would regularly attend monthly home-owners meetings held by the Beaver Creek Resort Company (BCRC), according to Kent Myers. At one meeting, Betty Ford raised her hand and asked politely if the weeds in their cul-de-sac could be addressed. The next day the flower crew was on the job. Betty Ford visits with John Horan-Kates at an event. (Courtesy of Vail Resorts, Inc.)

Ten

STAR STATUS

During the summer, Beaver Creek holds its annual arts festival. A longtime entertainer, Helmut Fricker plays his accordion on the Village Plaza at the arts festival. Recognized by locals, tourists, and celebrities, Fricker is a tradition in the area. He even entertained President and Betty Ford at their home while they had several European former prime ministers visiting. (Courtesy of Mike Rawlings.)

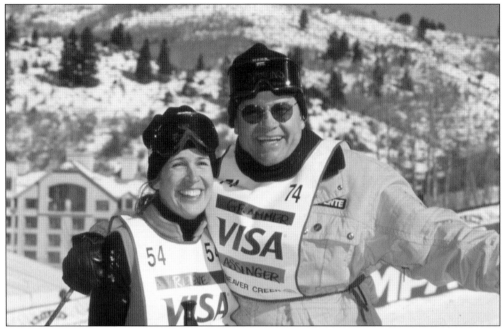

The American Ski Classic brought out the stars. Dana Reeve (left) is seen with Kelsey Grammer of television's hit series *Frasier*. Reeve was an actress, singer, and activist for disability causes. Grammer frequented Beaver Creek where he owned a mountain chalet. The home was featured in *Architectural Digest* in 2004. (Courtesy of Mike Rawlings.)

Tennis Hall-of-Famer Martina Navratilova joins in the winter spirit while skiing in the ASC. A phenomenal tennis champion during the 1970s and 1980s, she won nine singles titles at Wimbledon. Tennis was in her blood; her grandmother was an international tennis player and finalist at Wimbledon in 1962. (Courtesy of Mike Rawlings.)

Tommy Moe (left), an Olympic gold medal winner, is sharing strategy with fellow Olympic skier "Billy" Kidd. Born William Winston Kidd, in 1964, Billy became one of the first American men to get an Olympic medal in Alpine skiing in Innsbruck. Moe earned his gold in Lillihammer, Norway, in 1994. (Courtesy of Mike Rawlings.)

Mary Hart shares laughs with the press at the ASC in Beaver Creek. She is well known for being the face of the entertainment round-up program *Entertainment Tonight*. For 29 years, she hosted the longest-running syndicated magazine show of all time. Lloyd's of London once insured her well-admired curvy legs. (Courtesy of Mike Rawlings.)

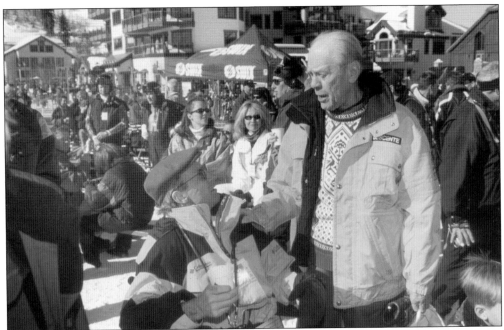

Jimmie Heuga (left) is seen spending time with the founder of the American Ski Classic, Jerry Ford. Heuga began achieving firsts by being the youngest to make the US Ski Team squad at age 15. He then became a star winning the bronze medal in Alpine skiing at the 1964 Olympics. Again, he was one of the first US men to medal in Alpine skiing. (Courtesy of Mike Rawlings.)

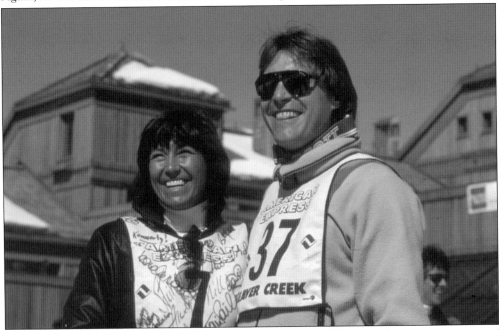

Local celebrities joined the festivities brought by the ASC. Sheika Gramshammer, co-owner of the Gasthof Gramshammer lodge and restaurant in Vail, is catching up with Jack Ford. Their families had been friends since the Fords started visiting in the valley in the 1970s. (Courtesy of Vail Resorts, Inc.)

Best known for cofounding the hair product line Paul Mitchell, John Paul DeJoria was a frequent celebrity skier at the ASC. An entrepreneur, he started Patron tequila distillery as a hobby, and now, it is known as a premium tequila brand. This only begins to tell the story of dozens of other companies he has started. (Courtesy of Mike Rawlings.)

Beaver Creek was designed not only for outdoor sports, but also for culture and building community. The Vilar Performing Arts Center (VPAC) became the venue to host the arts. Performers from around the world share their talents on the stage at the VPAC. Here, legendary B.B. King entertains a full auditorium with his band. (Courtesy of Zach Mahone.)

Phoebe and Bob Barrett view the skiing events at the ASC. Barrett served as chief of staff to former president Ford for many years. He also put together the first Jerry Ford Golf Invitational in Vail. Within seven years, the tournament had grown so large that they could not fit any more celebrities on to the roster. (Courtesy of Vail Resorts, Inc.)

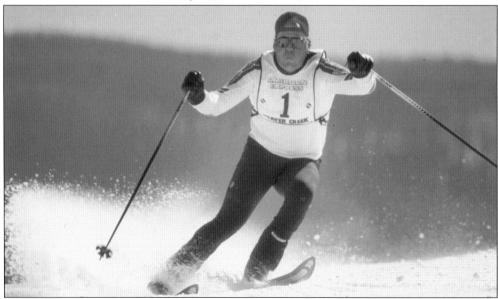

Moose Barrows is racing on the ASC course in the early 1990s. Barrows skied on the US Ski Team during the 1968 Olympics in Grenoble, France. He took a horrendous fall two-thirds down the course, earning him the famous "agony of defeat" tagline by the ABC *Wide World of Sports* show. (Courtesy of Vail Resorts, Inc.)

John Garnsey is partaking in the festivities at the ASC. Garnsey's ski industry career has spanned 40 years, including stints as an executive with the Vail Valley Foundation for 16 years, chief operating officer of Beaver Creek starting in 1999, and currently president of international growth for Vail Resorts. He was inducted into the Colorado Ski and Snowboard Hall of Fame in 2011. (Courtesy of Mike Rawlings.)

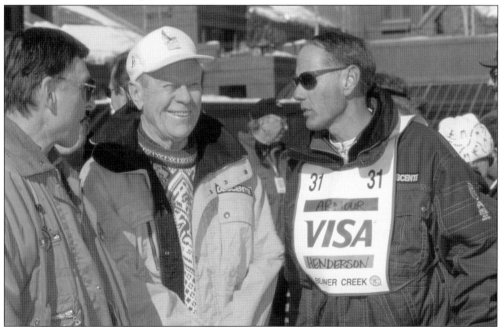

Conversations evolve between ASC spectators, from left to right, unidentified, Jerry Ford, and Bob Armour. Heavily involved in civic endeavors, Armour worked with Vail Mountain Rescue, the local search and rescue organization, for 18 years. In addition, he was very active in the town council for Vail, serving two years as mayor. (Courtesy of Mike Rawlings.)

Pepi Gramshammer is observing the colorful activity during the ASC. Gramshammer and his wife, Sheika, built a European-style hotel infused with charm in Vail. When he arrived in Vail, he was an international ski racing star. His involvement in the ski industry continued, and in 1990, he was inducted into the Colorado Ski and Snowboard Hall of Fame. (Courtesy of Mike Rawlings.)

Former Olympic Alpine ski racer Suzy Chaffee hugs Steve Ford in Beaver Creek. Chaffee, also known as Suzy "Chapstick," became a freestyle ballet skier in the early 1970s and led reform for Title IX legislation for women in sports. Actor Steve Ford, son of former president Jerry Ford and former first lady Betty Ford, joined the cast of *The Young and the Restless* and held roles in a number of films. (Courtesy of Vail Resorts, Inc.)

American ski legend Dick Durrance skis during the ASC. Durrance earned 17 national championships during his ski racing career. Off the slopes, he is known for his involvement with ski areas Sun Valley, Alta, Aspen, and Arapahoe Basin. He has been a member of the US National Ski Hall of Fame since 1958 and of the Colorado Ski and Snowboard Hall of Fame since 1982. (Courtesy of Vail Resorts, Inc.)

Well-known actor Clint Eastwood takes time to visit with young admirers after his ski run at the ASC. Eastwood was a regular participant in Jerry Ford's summer celebrity golf invitational. When Ford decided the golf tourney needed a winter counterpart, the Ford Celebrity Cup was created. The Ford Celebrity Cup would evolve into the American Ski Classic. (Courtesy of Vail Resorts, Inc.)

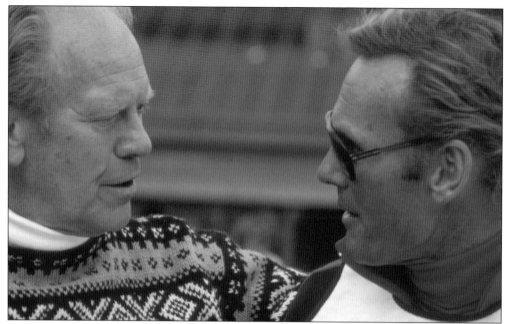

Playing host at his charity event, former president Jerry Ford (left) schmoozes with Tab Hunter, 1950s movie heartthrob. Ford, known for his congenial nature, put folks at ease when meeting them for the first time. Hunter appeared in several movies from the 1950s to the 1980s, earning him the nickname of "sigh guy," which extolled his "squeal appeal." (Courtesy of Vail Resorts, Inc.)

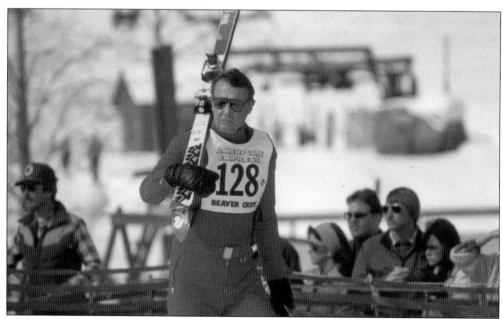

John "Bud" Palmer was a distinguished athlete during his college years at Princeton, earning the honor of Division I All-American in basketball, soccer, and lacrosse. He began his professional basketball career playing for the New York Knickerbockers. His career evolved into sportscasting where he covered many professional and Olympic events. A local homeowner, he developed numerous friendships and was involved in many charities. (Courtesy of Vail Resorts, Inc.)

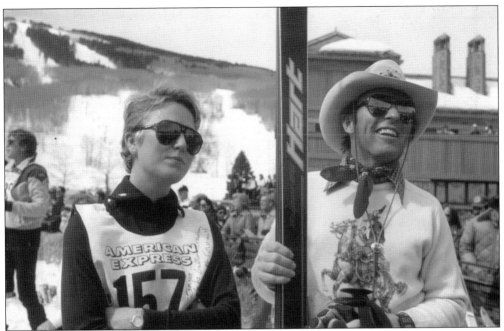

Two legends, Tanya Tucker and Billy Kidd, visit while participating in the ASC. At the age of 13, Tucker, an American country music star, recorded her first hit with the song "Delta Dawn." Her career includes several Top 10 and Top 40 hits. Kidd, wearing his iconic cowboy hat, evokes the Western lifestyle found in his hometown Steamboat Springs. (Courtesy of Vail Resorts, Inc.)

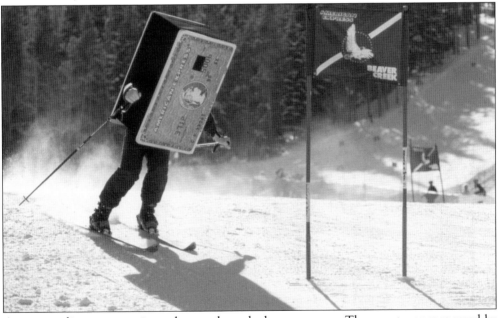

An extraordinary competitor schusses through the racecourse. The event was sponsored by American Express, and the company found a creative way to mingle with the other competitors. In the early 1990s, American Express/Shearson Lehman built an award-winning lodge in Beaver Creek called Saddleridge. Originally, it was built as a corporate retreat and has since become private residences with many amenities. (Courtesy of Vail Resorts, Inc.)

Robin and Andy Mill cozy up at the races. Robin Mill (née Ridenour) was a former Miss California, and her Colorado-born husband, Andy, was a two-time Olympian. A former US Ski Team racer, Andy competed mainly in the downhill and combined events on the World Cup circuit. (Courtesy of Vail Resorts, Inc.)

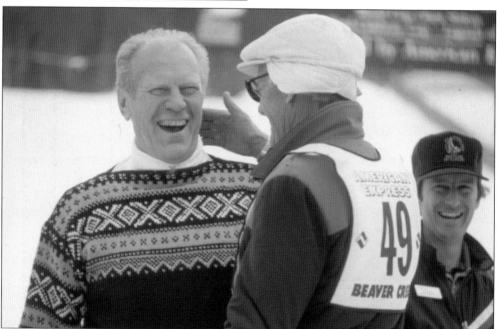

These two gentlemen share a friendship that spans decades. Here, former president Ford laughs with Fitzhugh Scott, Vail's original architect. Scott handpicked the location of his home in Vail, which would be the very first one built in the area. Years later, Scott's home would host a meeting Ford held with his advisors to discuss the 1976 presidential election. (Courtesy of Vail Resorts, Inc.)

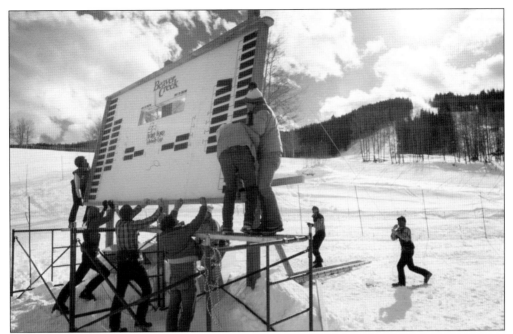

The Beaver Creek race crew is in a flurry of activity preparing for the Jerry Ford Celebrity races. Five-person teams go head-to-head moving through their respective pools to advance to the qualifying rounds. After two fun-filled days of racing, eight teams advance with only one being the winner. (Courtesy of Vail Resorts, Inc.)

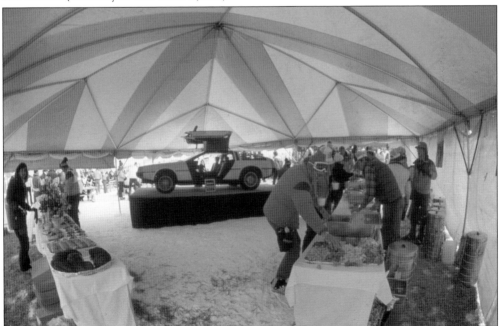

A VIP tent provides food and refreshments to the celebrities and legend racers. A DeLorean DMC-12 car is on display inside the tent. It featured gull-wing doors with a fiberglass underbody to which nonstructural brushed stainless steel panels were affixed. The car was featured as a homemade time machine in the *Back to the Future* movie trilogy. (Courtesy of Vail Resorts, Inc.)

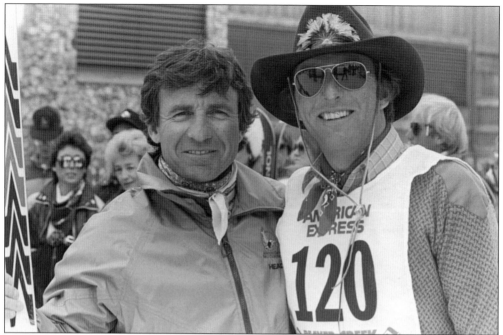

Former US Ski Team members Jimmie Heuga (left) and Billy Kidd are seen enjoying time together. They achieved history in 1964 by being the first American men to receive Olympic medals in Alpine skiing. Kidd brought home the silver, and Huega captured the bronze medal. At age 27, Heuga was diagnosed with multiple sclerosis, ending his ski career. He found the Can Do Multiple Sclerosis organization. (Courtesy of Vail Resorts, Inc.)

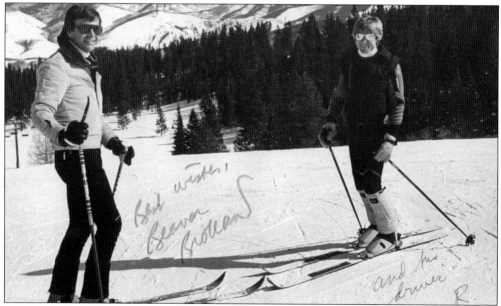

Beaver Creek ski school director Bob Dorf guided these two well-known skiers when they visited Beaver Creek. They humorously signed the photograph "Best wishes, Beaver Brokaw and his driver R." Dorf hosted a radio ski report where the name "Beaver Bob" stuck. Tom Brokaw (left) and Robert Redford continued with the shtick when they visited Dorf. (Courtesy of Bob Dorf.)

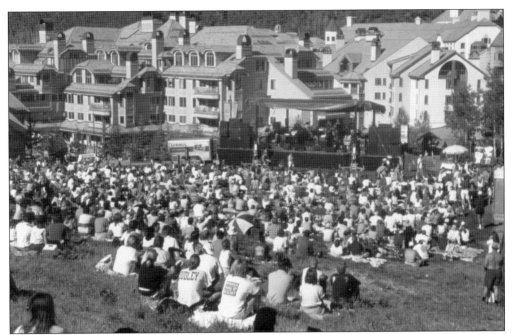

Summertime in Beaver Creek offers beautiful vistas, blue skies, and a plethora of outdoor activities. Concerts are offered free to all guests. The venues vary from lawn seating to taking the chairlift up to the mid-mountain restaurant Spruce Saddle. Performances include a wide variety of talent from established entertainers to fresh, new-on-the-scene bands. (Courtesy of Mike Rawlings.)

Beaver Creek provides a colorful setting for the annual Shaw Cancer Center's Fall Hike, Wine & Dine fundraiser. The easy four-mile hike on a golden aspen trail offers various gourmet foods provided by local restaurants. It is a fundraiser for a great cause, Jack's Place A Cancer Caring House, with a beautiful setting. (Courtesy of Zach Mahone.)

The famous Austrian Olympic skier referred to as the "Klammer Express" attends the ASC. Franz Klammer won the 1976 Winter Olympic downhill gold medal. He also dominated the World Cup downhill event, winning it in four consecutive seasons, from 1975 to 1978, with a fifth win in 1983. After he retired at the age of 31, he went on to establish the Franz Klammer Foundation for seriously injured athletes. (Courtesy of Mike Rawlings.)

George Gillett (left) is seen with Jean-Claude Killy, winner of the Triple Crown of Alpine skiing at the 1968 Winter Olympics. Killy secured gold medals in downhill, giant slalom, and slalom events at the Grenoble, France, Olympics. Gillett was owner of Vail Associates resorts, Vail and Beaver Creek. He infused friendly hospitality into the company and personally greeted guests while he was riding the chairlifts. (Courtesy of Vail Resorts, Inc.)

The Vilar Performing Arts Center provides free transportation and tickets to over 6,000 Eagle County school kids annually. An outreach program, STARS (Support the Arts Reaching Children), is designed to educate children in the performing arts. In-class workshops, as well as visits to the theater, are integral to the program. (Courtesy of Zach Mahone.)

Steve Ford (left) is chatting it up with Randi Oakes, fashion model and television actress, at the ASC. Oakes became famous for her role in the popular *CHiPS* show in the early 1980s. She appeared as a guest star in other series as well. Ford and Oakes had a common interest, as they were both actors. (Courtesy of Vail Resorts, Inc.)

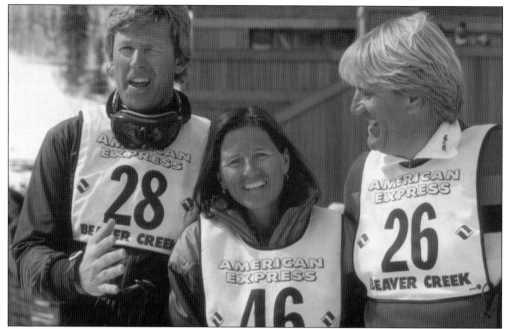

Friends and former Olympic skiers gather for a photo opportunity at the ASC. From left to right are Jan Helen, Anneliese Freeman, and Leif Grevle. Freeman skied on the 1960 German Olympic team, narrowly missing the bronze medal in the downhill. Grevle was a member of the 1964 Norwegian Olympic team. (Courtesy of Vail Resorts, Inc.)

Vail International Dance Festival featured several venues, including Village Vignettes, with BreakEFX performing in Beaver Creek. This hip-hop dance group invited kids from the audience to join in a dance routine on the plaza in Beaver Creek. BreakEFX competed in *America's Best Dance Crew* in 2010; however, they were eliminated in the West region finals. (Courtesy of Zach Mahone.)

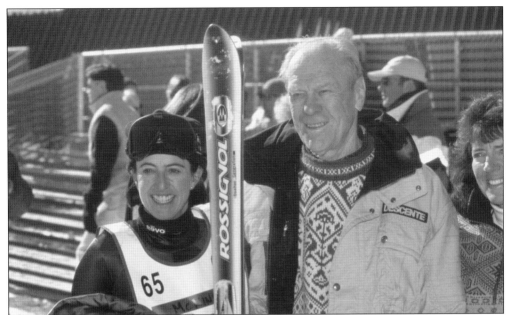

Former World Cup Alpine ski racer Tamara McKinney (left) is posing with former president Jerry Ford and an unidentified person at an ASC event. She competed in three Winter Olympic Games and is said to be one of the greatest American women ski racers. McKinney continues to share her love of skiing by coaching part-time for the Squaw Valley Ski Team. (Courtesy of Mike Rawlings.)

A man of many shades, Steve Haber decides to bring three different eyewear styles with him to the American Ski Classic. Haber founded Bolle USA eyewear, which he sold to pursue other interests. A segment in the market that was missing, in his opinion, was polarized eyewear. HaberVision was created, the first online-only premium eyewear company. (Courtesy of Mike Rawlings.)

123

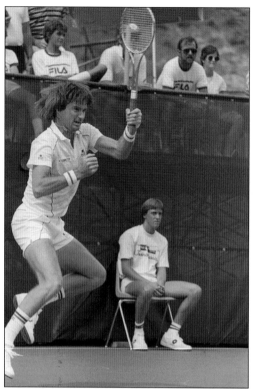

From 1983 to 1987, the Kiva Tennis Classic was held at Beaver Creek. The tennis tournament drew large crowds, including former president Jerry Ford and Betty Ford. The classic was delayed in 1987 for over five hours due to rain. Jimmy Connors played in the event in 1983, 1985, and 1987, winning it each year. (Courtesy of Vail Resorts, Inc.)

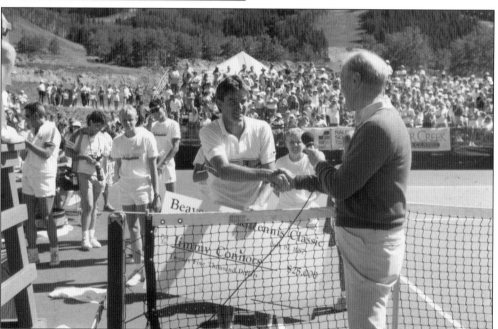

Former president Ford congratulates Jimmy Connors for winning the tennis tournament. Winnings for the Kiva Tennis Classic were reported to be $100,000. During the period Connors played in this event, he was ranked No. 3 in the world in 1983 and No. 4 in both 1985 and 1987. (Courtesy of Vail Resorts, Inc.)

The 33rd annual Beaver Creek Tree Lighting Ceremony was held November 29, 2013. This is the kick-off to the holiday season in Beaver Creek. A full evening of activities includes lighting the 38-foot tall tree, music, poetry readings, and fireworks. From left to right, Mary and Nancy Yoder are seen enjoying the holiday festivities. (Courtesy of Nancy Young.)

Beaver Creek opened with a young, enthusiastic staff. Many were new to the valley, and some were "drafted" from the mother ship of Vail Mountain. Penny Lofaro was one of three mountain hostesses on Beaver Creek Mountain in 1980, previously a Vail hostess. Their focus was to answer guests' questions, help ski patrol, and ensure skiers enjoyed their time on the mountain. (Courtesy of Vail Resorts, Inc.)

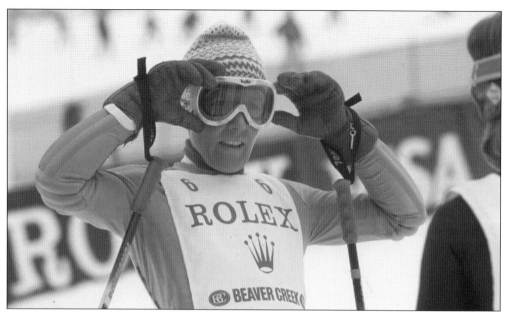

Originally from Minnesota, Cindy Nelson was the first American to win a World Championships downhill race. Also to her credit is an Olympic bronze medal in downhill, one of many accomplishments over her 14-year international racing career. Nelson was inducted to the Colorado Ski and Snowboard Hall of Fame in 2002. (Courtesy of Mike Rawlings.)

The Beaver Creek presidential home of Jerry and Betty Ford went under contract in late 2006. A California businessman bought the property and began a major renovation. The owner added touches that would imbue a distinguished quality to the home, such as the presidential seal, which was carved into the entryway hall. (Author's collection.)

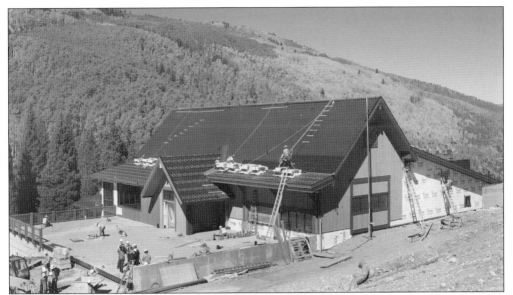

Pictured here, construction pushes forward on the deluxe new Talons restaurant at the base of the World Cup venue. Built with 500 seats inside and 250 seats on the outdoor deck, it also features an indoor and outdoor bar and outdoor smokehouse. Opened in 2013, it is ready for the 2015 World Alpine Ski Championships at Beaver Creek. (Courtesy of Dominique Taylor for *Vail Daily*.)

The summer of 2012 marked the start of construction on the ladies' downhill course at Beaver Creek. Giving the thumbs up in the cab is Ceil Folz, president of the 2015 World Championships. Standing are, from left to right, Greg Johnson, men's chief of race; Harry Frampton, member of the 2015 executive committee; Jim Roberts, ladies' chief of race; and Tim Baker, of Beaver Creek Resort Company. (Courtesy of John Dakin.)

DISCOVER THOUSANDS OF LOCAL HISTORY BOOKS FEATURING MILLIONS OF VINTAGE IMAGES

Arcadia Publishing, the leading local history publisher in the United States, is committed to making history accessible and meaningful through publishing books that celebrate and preserve the heritage of America's people and places.

Find more books like this at
www.arcadiapublishing.com

Search for your hometown history, your old stomping grounds, and even your favorite sports team.